ANGOLA

Journey through change

Front cover:
Thirteen-year-old Candre Antonio stood on a landmine buried outside his house.
His father, looking to defend himself and his family, had planted the mine.

First published in the United Kingdom in 2007 by
Dewi Lewis Publishing
8 Broomfield Road, Heaton Moor
Stockport SK4 4ND, England
www.dewilewispublishing.com

© 2007
for the photographs: Sean Sutton/MAG
for the texts: Lou McGrath, Heather Mills, Tim Page, Sean Sutton, Benita Ferrero-Waldner
for this edition: Dewi Lewis Publishing

ISBN 13: 9781904587439

Design: Sean Sutton & Dewi Lewis
Production: Dewi Lewis Publishing
Print: EBS, Verona, Italy

http://ec.europa.eu/comm/external_relations/mine/intro/index.htm

www.magamerica.org

www.magclearsmines.org
Charity no: 1083008. Company no: 4016409

MAG is grateful to EuropeAid and MAG America for their support in funding this publication

ANGOLA
Journey through change

photographs

Sean Sutton

texts

**Heather Mills, Tim Page
Lou McGrath, Sean Sutton
Benita Ferrero-Waldner**

text editor

Geoff Turner

Dewi Lewis Publishing
in association with MAG

We have all been touched by images of people who are suffering from the effects of anti-personnel mines and remnants of war. This is why combating this scourge has been a priority of the European Commission in recent years and why the international community needs to sustain its efforts in this area.

This photobook by award-winning photojournalist Sean Sutton looks at the work of MAG, which is contributing to the fight against landmines around the world. The European Commission is proud to support the work of MAG in Angola.

The book illustrates what humanitarian mine action involves, from digging out landmines and teaching local people how to live more safely in dangerous areas, to rehabilitating and reintegrating a young victim into the community.

The pictures show us that the combination of mine clearance, disposal of bombs and munitions, and redeveloping the land and infrastructure works to support and build peace. The need to relegate images such as those in this book to the past and to create a safer, more secure and prosperous future for all people requires us to continue supporting efforts to prevent anti-personnel landmines from making new victims. The European Commission will pursue its efforts in this direction and calls on the international community to do the same.

Mrs Benita Ferrero-Waldner, Commissioner for External Relations
European Commission

ANGOLA – 40 years of conflict

1961-1975: Struggle for independence from Portuguese rule.

1975: Portugal grants independence to Angola, with the MPLA becoming the de facto government. Conflict erupts between the MPLA, FNLA and UNITA.

1975-1991: Extended period of civil war between the Government, backed by the Soviet Union and Cuba, and UNITA, backed by South Africa and the United States.

1981-1983: Large-scale incursions by SADF against the Namibian independence movement, SWAPO, which had many bases in southern Angola.

1985: South African forces invade again, this time in support of UNITA.

1988: Cuban troops withdraw from Angola as South African troops withdraw from Angola and Namibia.

1991: Both the Government and UNITA agree to the holding of UN-monitored elections under the Bicesse Accords, bringing the 16 year civil war to an end.

1992: UNITA returns to war after contesting the outcome of the elections.

1994: An uneasy peace is restored following the signing of the Lusaka Protocol by both parties.

1998: Civil war recommences throughout Angola following Government offensives against UNITA strongholds.

2002: UNITA leader Jonas Savimbi is killed in an ambush. This leads to a cease-fire, armistice and peace.

Glossary of Acronyms

MPLA: Popular Movement for the Liberation of Angola

FNLA: National Front for the Liberation of Angola

UNITA: National Union for the Total Independence of Angola

SADF: South African Defence Force

SWAPO: South-West Africa People's Organisation

UN: United Nations

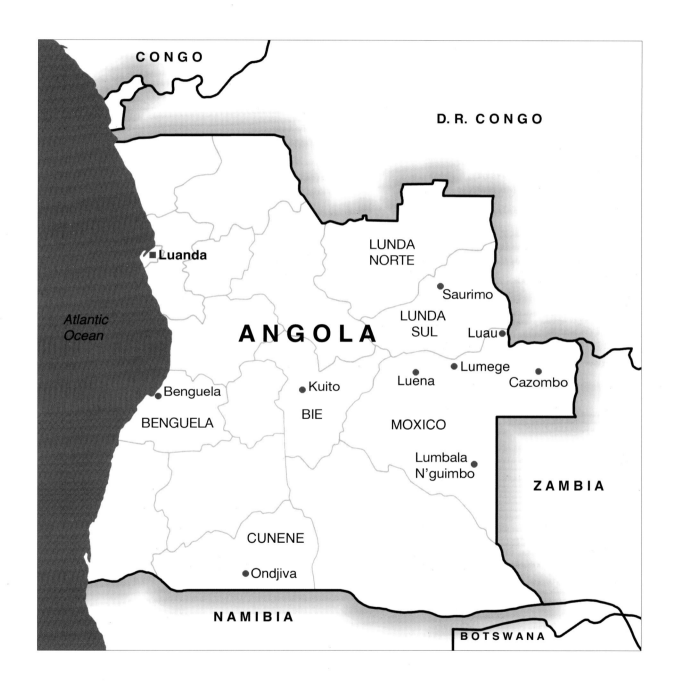

An Introduction to MAG

MAG is a conflict recovery organisation providing communities affected by conflict with a real chance for a better future.

MAG detects and clears the remnants of conflict from some of the world's poorest nations. Landmines, unexploded bombs and ordnance, small arms and light weapons, abandoned and dangerous stockpiles and caches of weapons and munitions contaminate the landscape following conflict. They kill and maim civilians, restrict access to clean, safe water and land for cash-crops, orchards and sustained cultivation, prevent the re-establishment of education and healthcare facilities, and jeopardise the rebuilding of infrastructure from power lines to bridges and roads.

Removing the remnants of armed conflict means that people can regenerate, rebuild, and redevelop without fear of death or injury. MAG's unique Community Liaison approach, which ensures community involvement in the clearance process, produces results that impact directly and swiftly on the real needs on the ground. Put simply, our work means people can recover from conflict.

MAG's flexible, multi-disciplinary approach means that the organisation is able to respond to emergency situations such as Lebanon and Iraq, contribute to longer-term development projects in Cambodia and survey and clear suspect and dangerous items for bridge-building projects, road construction, power-line repair and the like, all of which are shown in this book.

Since 1989, MAG has operated in more than 35 countries. Today, MAG has 2,500 national staff supported by 100 international trainers and managers. 30 people manage and co-ordinate the organisation from its headquarters in Manchester, UK.

MAG is also co-laureate of the 1997 Nobel Peace Prize, awarded for its work with the International Campaign to Ban Landmines in achieving a ban on anti-personnel mines.

MAG in Angola

'The one who throws the stone forgets; the one who is hit remembers forever.' – Angolan proverb

MAG has been working in Angola for more than ten years and on many occasions has come face to face with the effects that the aftermath of conflict has on an impoverished population. Sean Sutton's images eloquently capture the myriad feelings of a nation that has struggled so long for peace and the people who live surrounded by the daily threat of death or injury as a result of landmines, bombs and other unexploded weapons.

Angola is emerging from nearly 40 years of bloody conflict. Following the peace agreement in 2002 hundreds of thousands of refugees began the journey back to their homelands from neighbouring Zambia, Namibia and the Democratic Republic of Congo. Mined roads and roadsides, and destroyed bridges still present a significant obstacle to post-conflict recovery, and the presence of minefields around many of the major population centres continues to place intense pressure on land for agriculture and resettlement.

MAG saves lives and builds futures. A specialist in conflict-recovery, MAG is playing a key role in assisting the safe return and reintegration of refugees. Land is steadily being cleared of deadly mines and ordnance for cultivation and construction; bridges are being rebuilt, roads and tracks made safe. Vital social services are being re-introduced and utilities and community centres being re-opened safely. An example of just one such clearance task took place around a water filtration and pumping station. Making the area safe allowed the local authority to repair the station and provide a fresh water supply to the city of Luena, benefiting more than 300,000 people.

The organisation began operations in the eastern province of Moxico in 1994 and by 1998 there were more than 400 staff providing landmine clearance and education programmes. Intense fighting in the area forced MAG to set up in Cunene in the south of the country, where more than 60 minefields were cleared by 2004. As the security situation slowly improved in 2000, MAG returned to Moxico to pick up its support for the population.

By removing the physical threat of injury and death, providing education programmes, and returning safe land and infrastructure, MAG helps communities to live their lives free from the suffering caused by the remnants of conflict.

Sutton's book is a visual reminder of MAG's journey alongside the Angolan people so far. There are pictures of hope beside those of despair and tears next to those of laughter. In many ways the journey has only just begun, and it's a journey with many challenges and difficulties ahead. With more landmines being cleared daily and more communities able to safely build homes, farm land and send their children to school, Angola is now taking steps towards a more positive and peaceful future.

Lou McGrath, Executive Director, MAG

Landmines – an ongoing problem

There is a common misconception that the problem of landmines had been solved by the late 1990s. The images in this book are stunning and graphic proof that this isn't the case – statistics show that every 30 minutes someone somewhere is killed or maimed by a landmine or item of unexploded ordnance. I have been involved in the landmine issue now for more than 13 years and the fact is that innocent people are still suffering horrific, sometimes fatal injuries due to the remnants of armed conflict. Civilian men, women and children in countries like Angola are desperate to survive, living day-to-day with the danger literally on their doorstep. Much of the population lives in poverty because their land remains contaminated years after the official ceasefire has been signed.

Landmines are barriers to the development of war-affected countries and communities. The Mine Ban Treaty has now been signed and ratified by 152 nations, and the major non-signatory countries (such as the USA and China) have landmine export bans in effect. Whilst I would like to see all countries sign the treaty and move on to banning or restricting the use of anti-vehicle mines and cluster bombs, we should remember that the reality is that very few anti-personnel landmines are now being exported. This means that we have the opportunity to actually solve a problem affecting the developing world and solve the problem for good. Every community that is freed from the scourge of landmines is a community able to live free from fear.

I'm often frustrated by some of the myths surrounding demining. One of these is that machines can solve the problem overnight. As a result of my experiences in the Balkans in the early 1990s I have a built-in suspicion of complex high-tech solutions over low-tech, more sustainable ones. Developed countries do have a tendency to try and find high-tech James Bond-type fixes for the problem. Whilst I applaud any progress that helps the efficiency of demining, I can't help feeling that the huge amounts of money spent on research and development could be better spent on clearing the landmines right now. The ability to maintain such equipment in countries and climates as diverse as Afghanistan, Angola, Sudan and Vietnam has to be questioned. More basic machinery can be used to clear vegetation, reduce the area that is suspected of being contaminated and verify that the land has been cleared.

This leaves us with the reality that manual demining is still (and likely to remain) our best option. But the manual approach has many other benefits. It relies on the simplest of tools, alongside patience and concentration. It also involves local people in solving their own problem and provides much needed work in countries where unemployment and poverty are widespread. How many more lives would have been saved and will be saved if we put a higher proportion of our resources into a solution we know works (manual demining) as opposed to the Holy Grail-like search for a highly technical space-age solution? The courage and determination of the Angolan people living with landmines is shown in so many pictures in this book.

So where does all this leave you and me in terms of helping to solve this problem and solving it sooner rather than later? I believe that as individuals we can and must show our leaders the way forward. After all, if it had been left to politicians alone the Mine Ban Treaty would not have been established in the first place. We must do the right thing and support charities such as MAG who can deliver immediate sustainable solutions, whilst pressing our leaders to get into the habit of clearing up the aftermath when war is judged (rightly or wrongly) as the only course of action. The leaders of the West found the necessary methods and resources when explosive remnants of war littered Europe in 1945, and posed a significant barrier to the economic and social development of the continent. Perhaps we should aspire to showing the same leadership now to ensure that the needless injuries like those suffered by so many of the people depicted in this book are truly a thing of the past.

Heather Mills

War and Photography

As a photo-journalistic child of the 60s, it is both comfortable and reassuring for me to find, reflected in the pages of this book, a clear sense that the work of previous generations is bearing fruit. The seeds were planted by Bert Hardy and George Rodger, and in turn gave life to the likes of Philip Jones Griffiths and Don McCullin, John Reardon and especially LIFE magazine's Larry Burrows. Sean Sutton's work reflects this same iconic imagery, one generation further down the line. The baton has been passed to the future believer, an impassioned portrayer of humanity's plight, hoping that a still picture or an essay will sway at least some of the audience.

Readers need to understand the impact, pre-television, that weeklies like LOOK, LIFE and PICTURE POST could have – just like the old Sunday supplements used to do. In such magazines hard-core issues were cover material. That was before celebrities ruled our consumer culture and dominated the covers of our magazines. The old tradition inhabits Sutton's work, reminding me not only of Burrows, but also a dash of Gilles Peress and a large dose of Henri Huet. Henri and Larry perished in Laos in 1971, with two other photographers, shot down over the Ho Chi Minh Trail.

MAG is now working to clear that most heavily *bombed* part of the planet: two million tons of ordnance was dropped on Laos, up to 30 per cent of which failed to detonate leaving a legacy of unexploded munitions and bombs.

Angola has the dubious distinction of being the most heavily *mined* country in the world.

Sutton deserves a Robert Capa Award for his work in some of the most dangerous situations you can possibly envisage. It is an honour to salute a comrade in 'photographic' arms and to watch his continued passion in pursuit of making a degree of difference. His images have captured the innocent bystanders and forgotten victims of war. I hope that Sutton's images will not just be viewed as a passive reminder, but as a call for justice and the banning of landmines forever.

Tim Page, Photographer

Journey Through Change

I first travelled to Huambo and Kuito in the centre of the country and to Luena in the east in late 1995. Although there had been a period of peace for over a year, Luena, the provincial capital of Moxico, was still under siege. It was a desperate situation. Tens of thousands of people displaced by the conflict were living in terrible conditions. Every inch of floor space that had a roof — the cinema, the railway station and the museum — was crammed full of hungry people.

Even though the guns were not firing, the town was under siege by successive rings of minefields. Some had been laid by UNITA to deny people access to arable land, and some by the Government to defend their positions and the town from attack. People were being blown up every day trying to get food, firewood and water. Two Vietnamese doctors, with no painkillers and no antiseptic, did their best to patch up the survivors. Maggots played a primary role in keeping the wounds clean. The hospital stank.

Other than Médecins Sans Frontières, which ran an emergency project for malnourished children, MAG was the only aid agency working in Luena at the time. They were revered by the population and crowds screamed and waved when they drove through town. It was the dedicated staff of MAG that broke the siege and it was incredible to see. Working in close liaison with the affected community, MAG achieved maximum benefits with the resources they had. Their approach also demonstrates that it is the beneficiaries that matter rather than the number of mines and metres cleared. Despite a return to war from mid-1998 to Savimbi's death in early 2002, what were once fields of death are now thriving neighbourhoods and luscious gardens.

Since 1995 I have been back to Angola six times revisiting communities and documenting their plight during and after the conflict. It has been a turbulent and difficult period but despite the suffering I have witnessed I have always come away heartened by my experiences.

An enduring quality of the Angolan people that has always amazed me is their intrinsic ability to laugh and dance despite their extreme circumstances. People love to be photographed. Women would run towards me, sometimes hundreds of metres, holding their babies forward for a photograph. Trying to catch a candid photo without kids in the foreground gesturing in kung fu poses was always a challenge. A few words in the local dialect would always get people laughing hysterically. "The foreigner speaks Chokwe! Come and hear it!" they would scream across the neighbourhood. Sure enough, crowds would gather to hear my few stuttering words and then burst into delighted giggles. You will never a find warmer and more welcoming people.

Sean Sutton

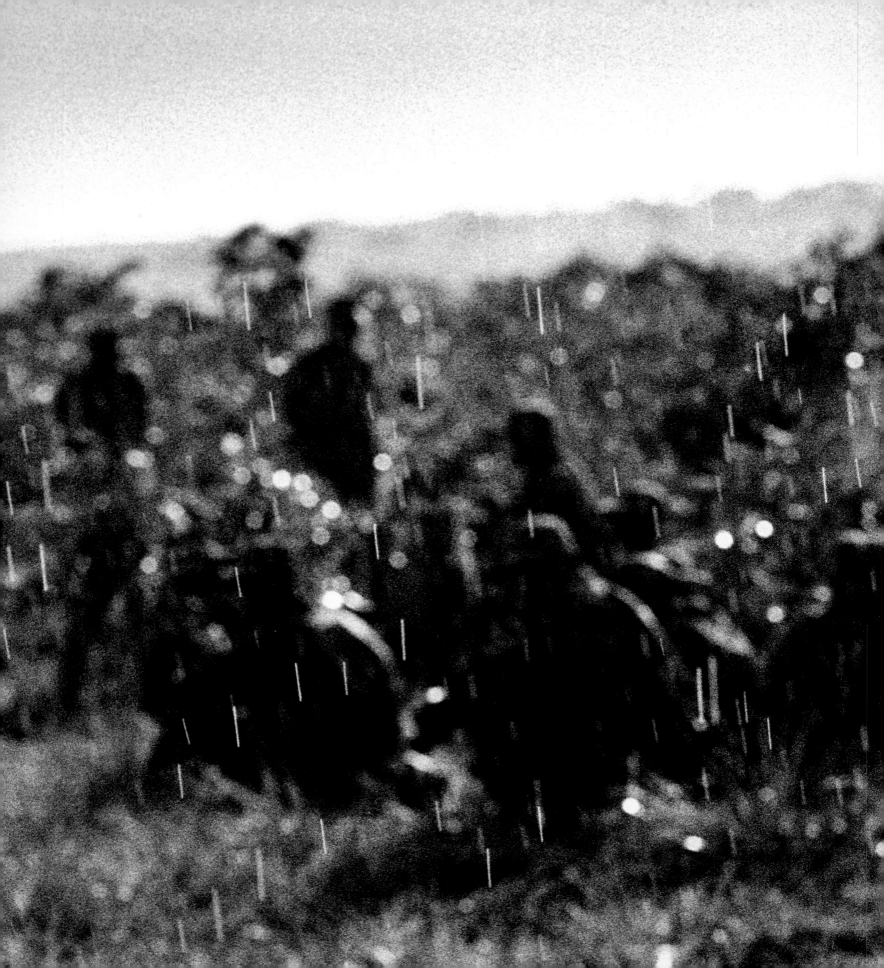

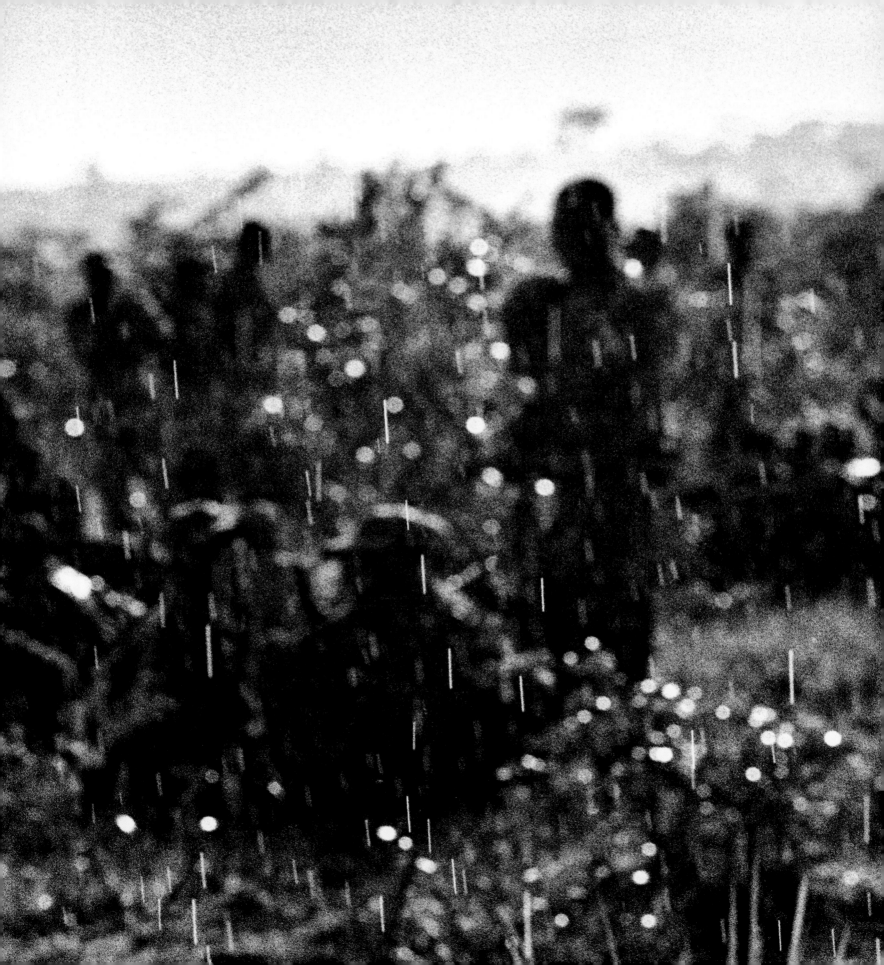

Previous page: Government soldiers in the rain during operations against UNITA.

This page: Ready for action: Soldiers on their way to the front line.

Next page, top left: Government troops on parade.

Bottom left: Angolan Government troops fire mortar bombs during the final offensive against UNITA.

Right, top and bottom: Troops preparing an ambush, linking the mines with detonating cord. The system was 'command operated' – soldiers hiding in the bush would trigger the ambush when an enemy convoy approached.

All photos Moxico, 2001

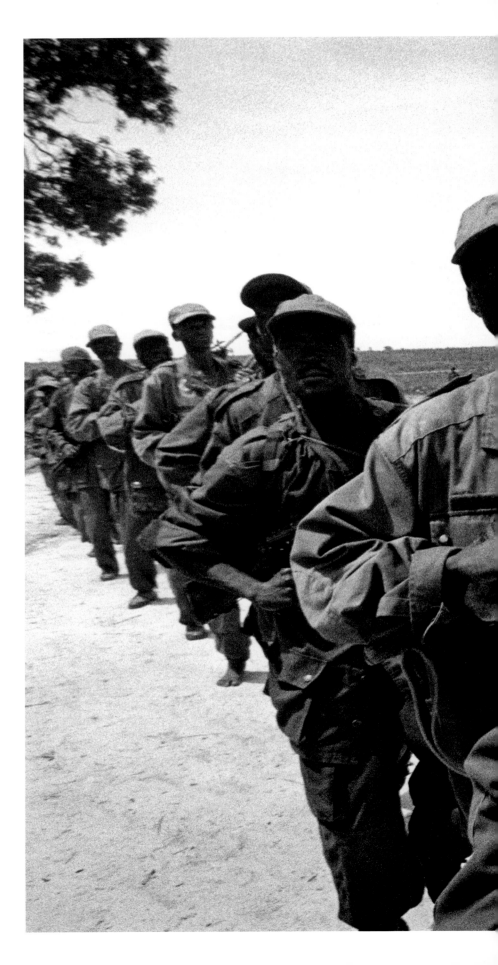

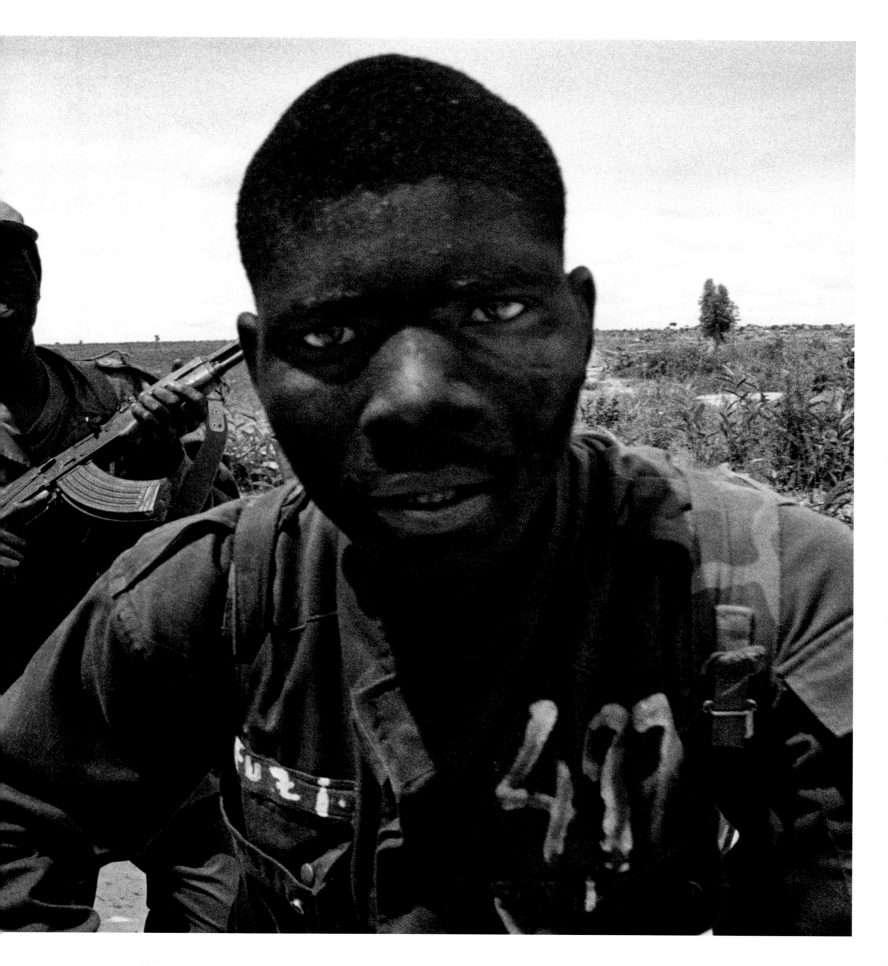

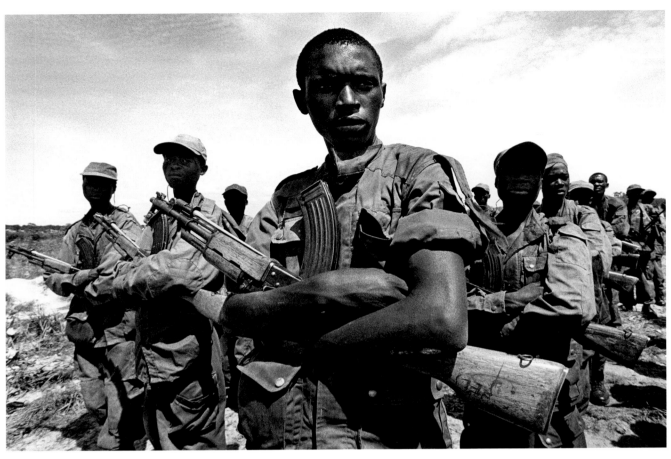
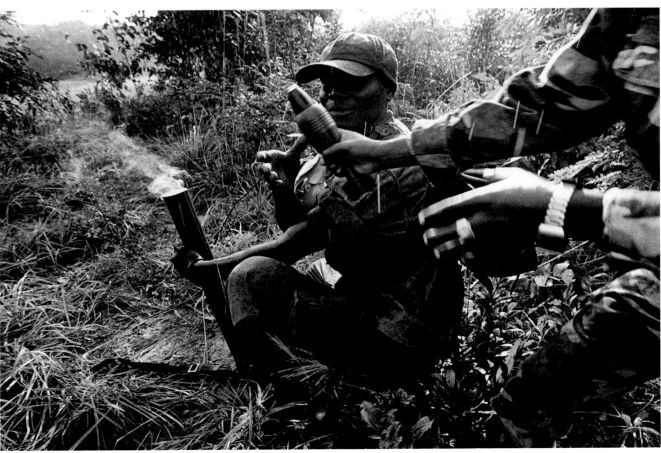

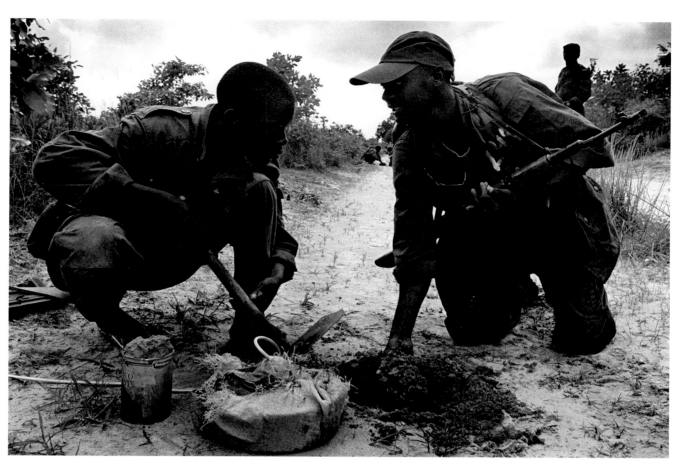

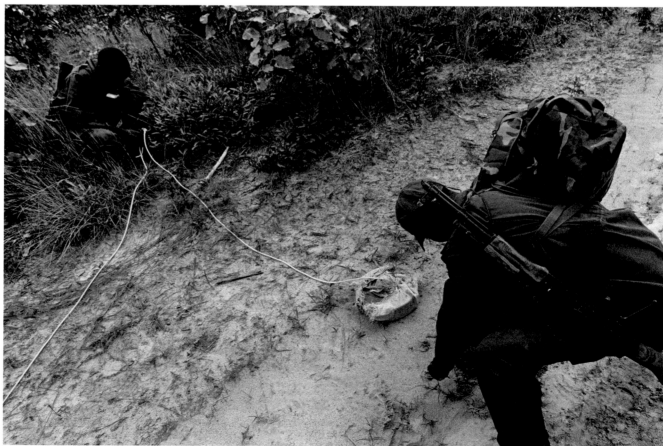

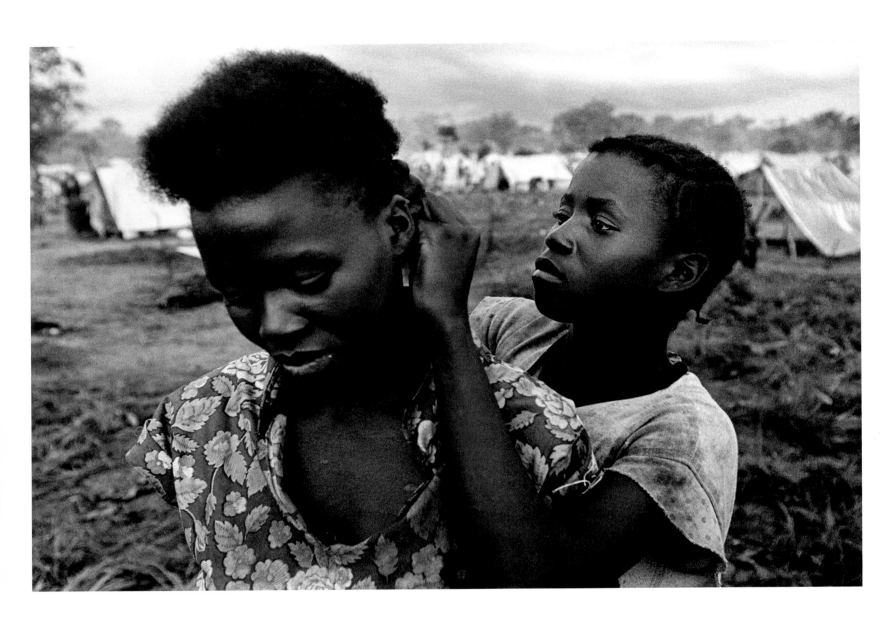

Muachimbo camp for internally displaced people – the situation was desperate.
These people had fled the ongoing offensive against UNITA and many had spent
months on the road. They were in a terrible condition.
Luena, 2001

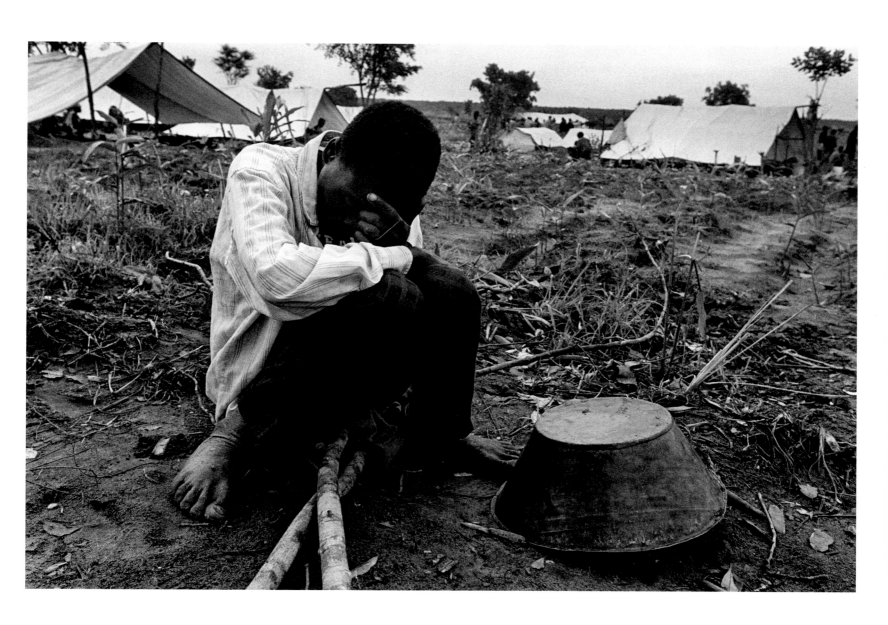

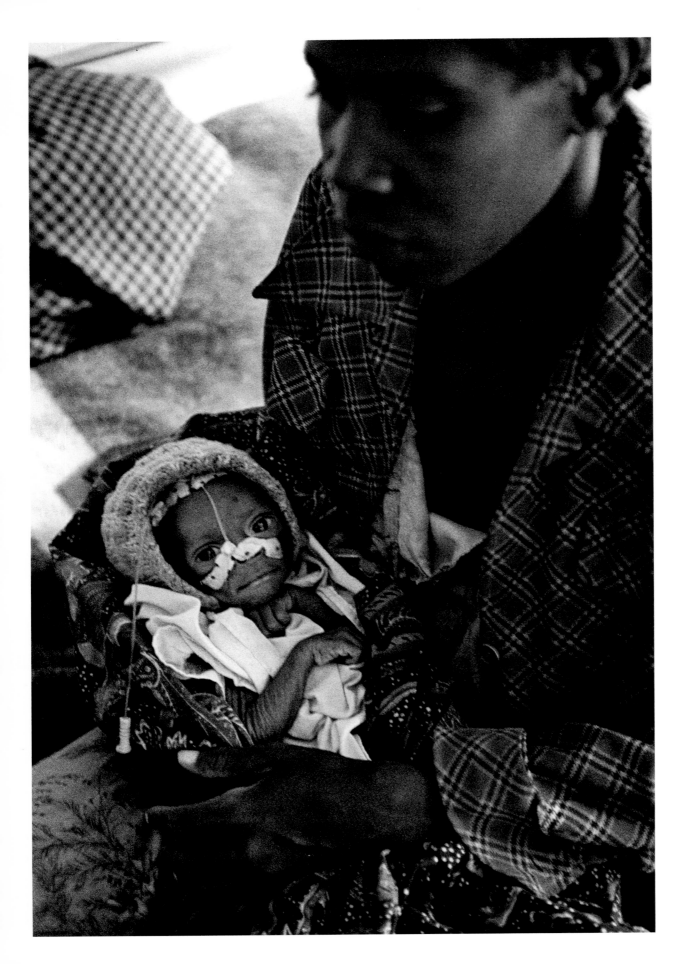

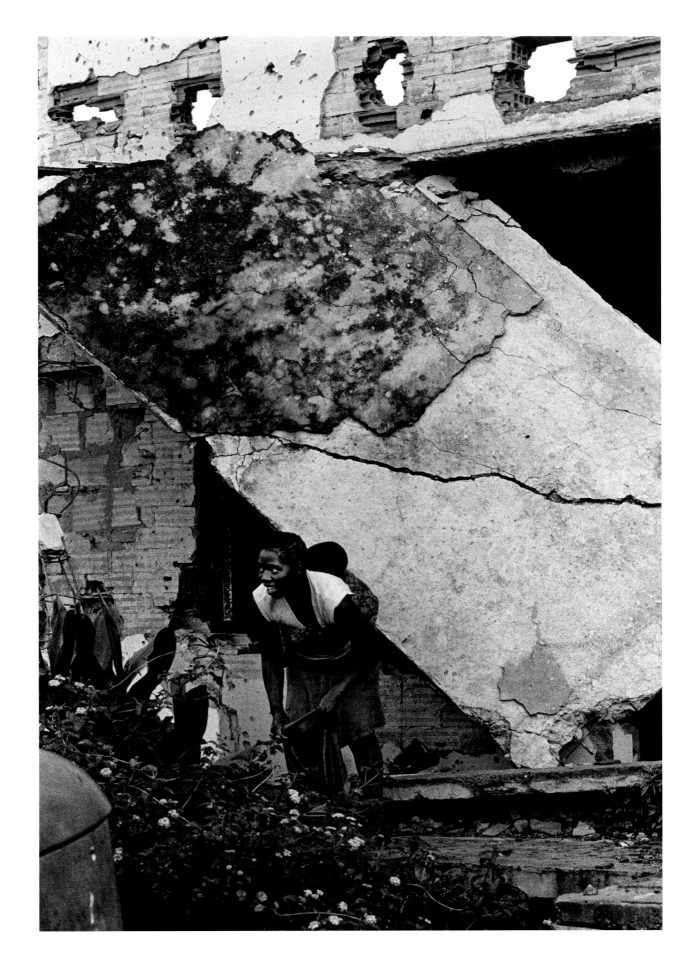

Previous pages, left: ICRC clinic for malnourished children.

Right: The town of Kuito was utterly destroyed by months of street to street fighting in the early nineties.

Right: Swinging high amongst the ruins of Kuito.

All photos Kuito, 1995

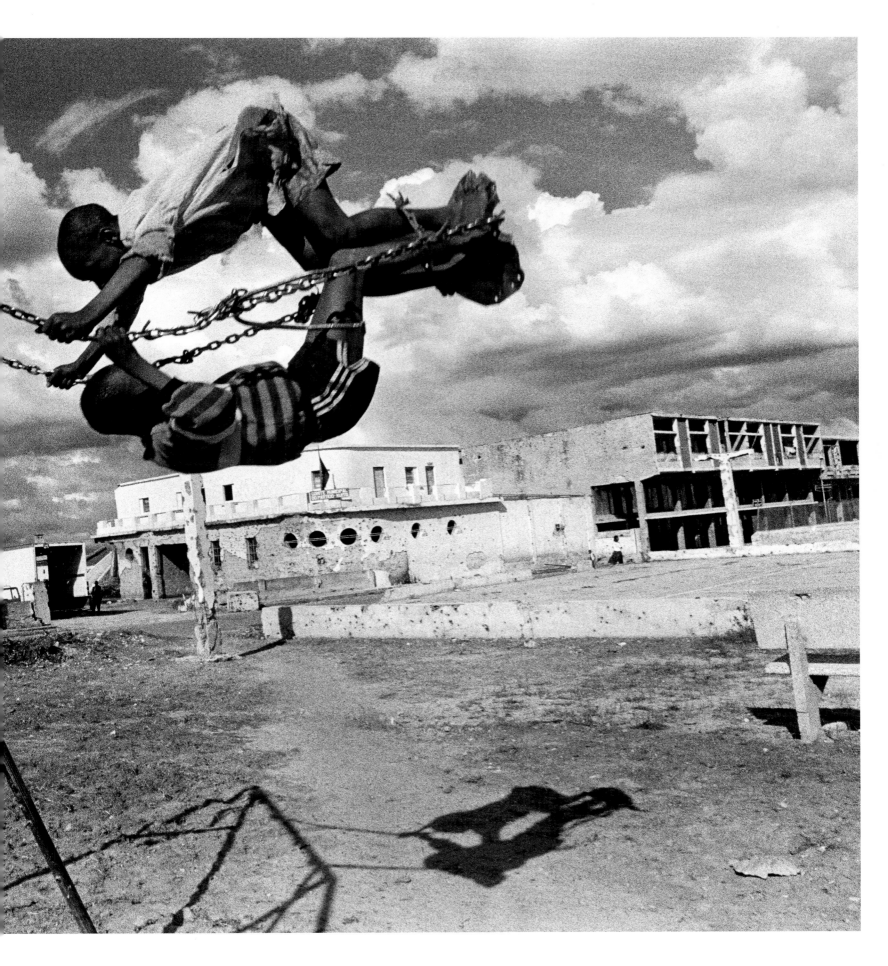

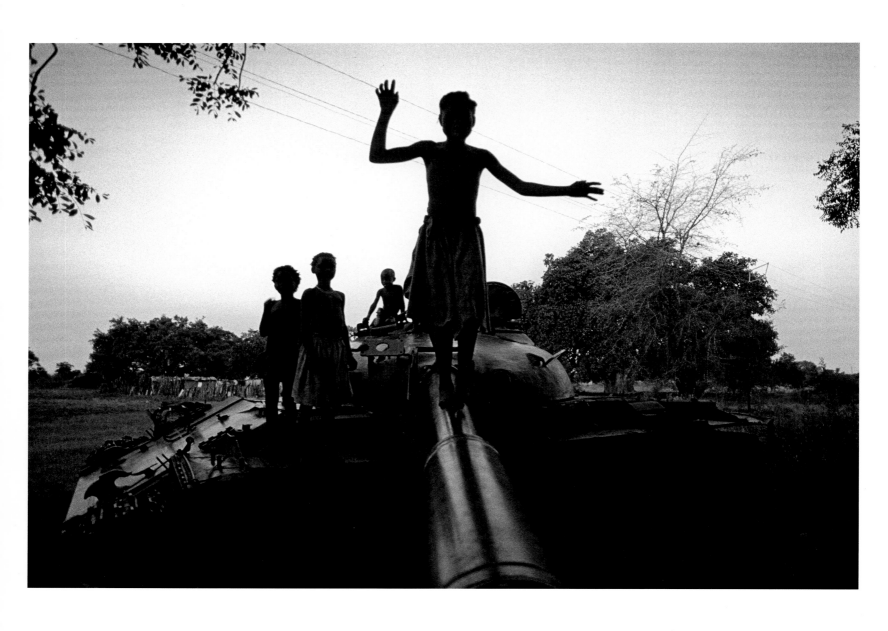

Children had been playing on this abandoned tank for years. A MAG team
checked it and found it was still fully loaded with live ammunition.
Ondjiva, 2000

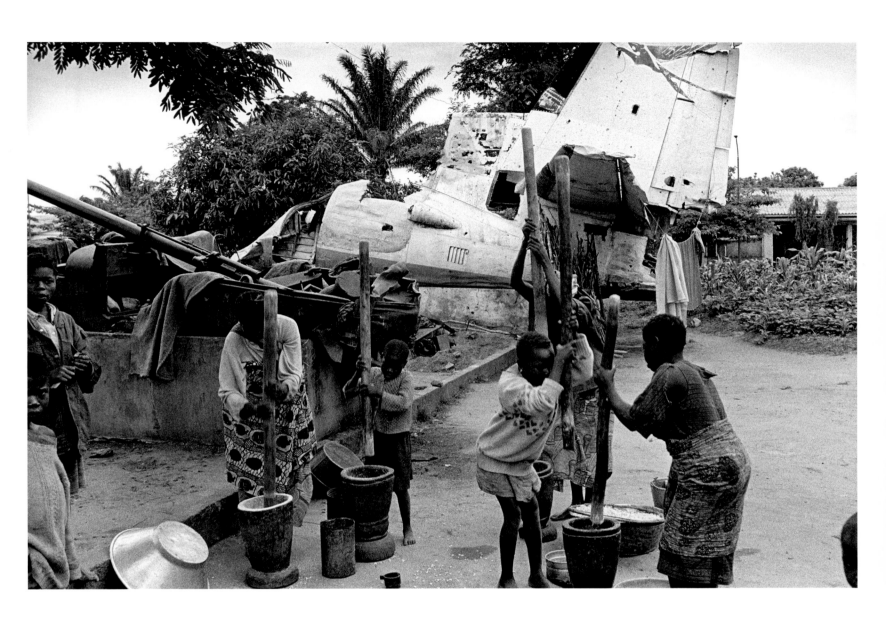

Pounding cassava into a powder, next to the remains of a South African bomber.
The powder is mixed with water and cooked to make the Angolan staple dish: funge.
Luena, 1995

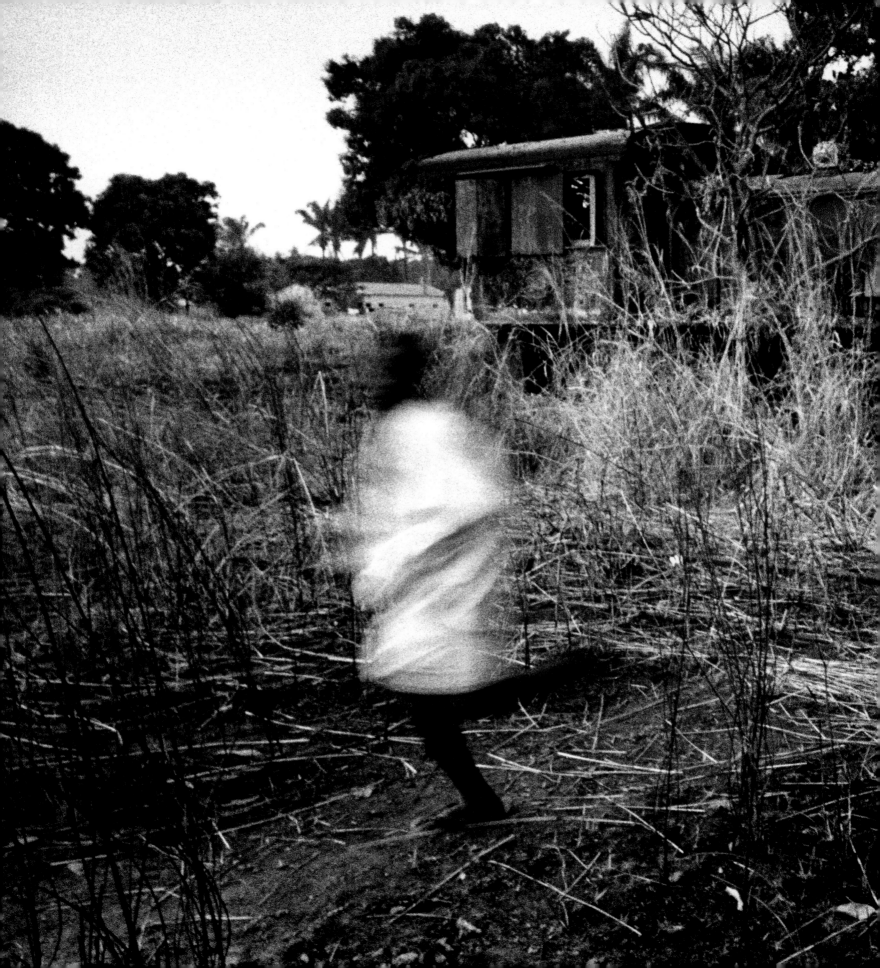

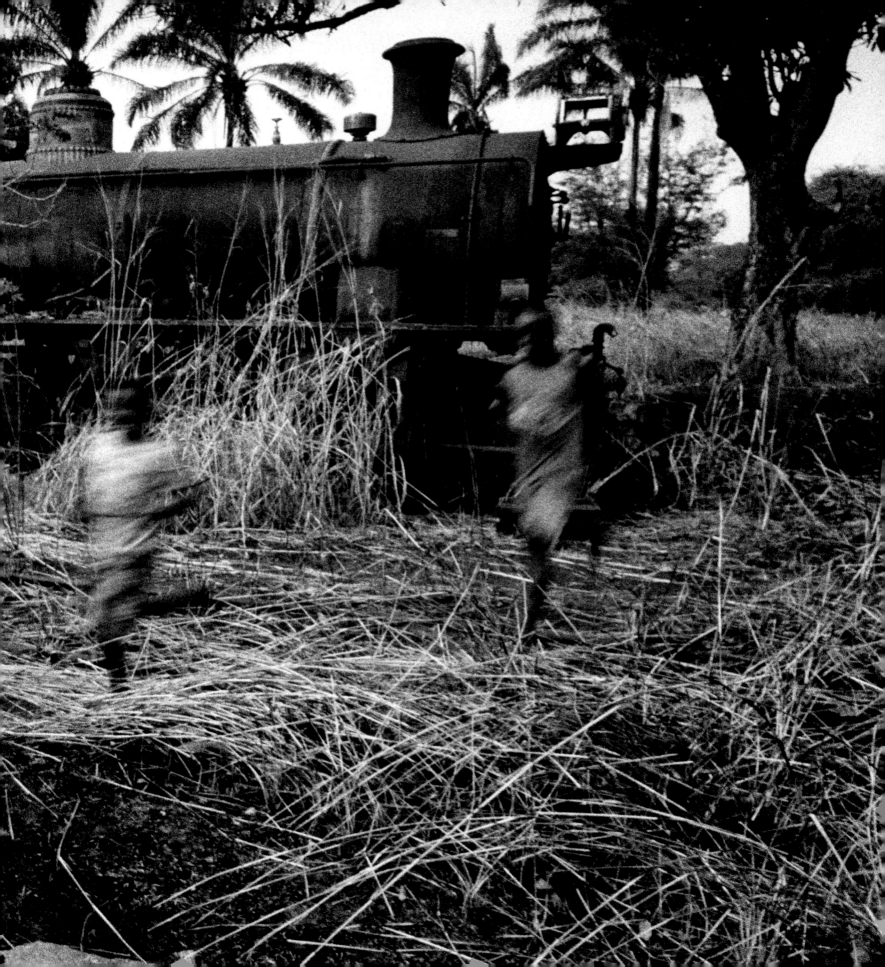

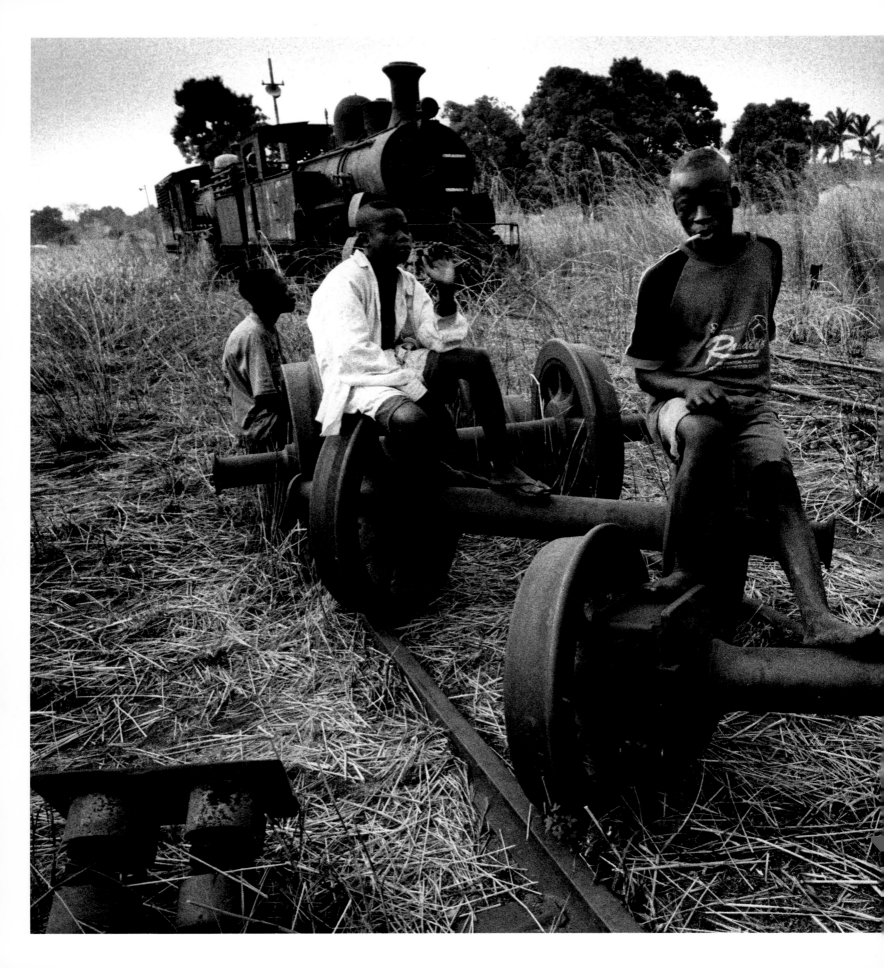

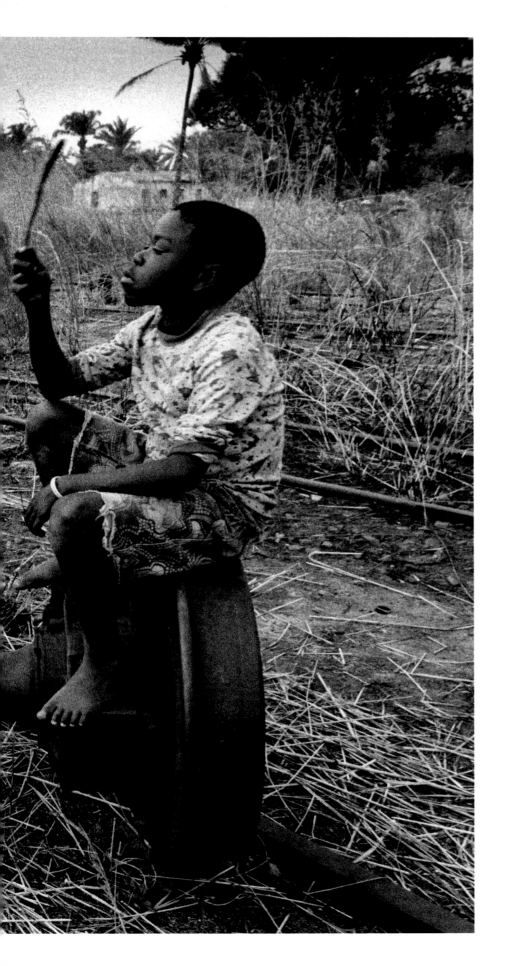

This page and previous page:
Children play amongst the rusting
remains of trains. The Benguela
railway ran across from Angola's
east coast to Zambia and the
Democratic Republic of Congo. The
last train left Luau station in 1983.
Luau, 2004

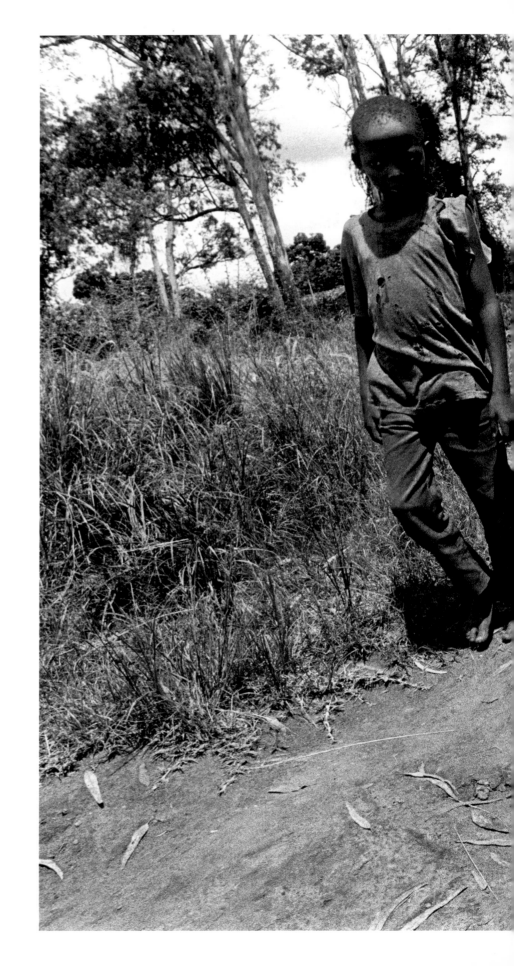

Pedro Domingus stood on a mine
when he was four years old.
Luena, 1997

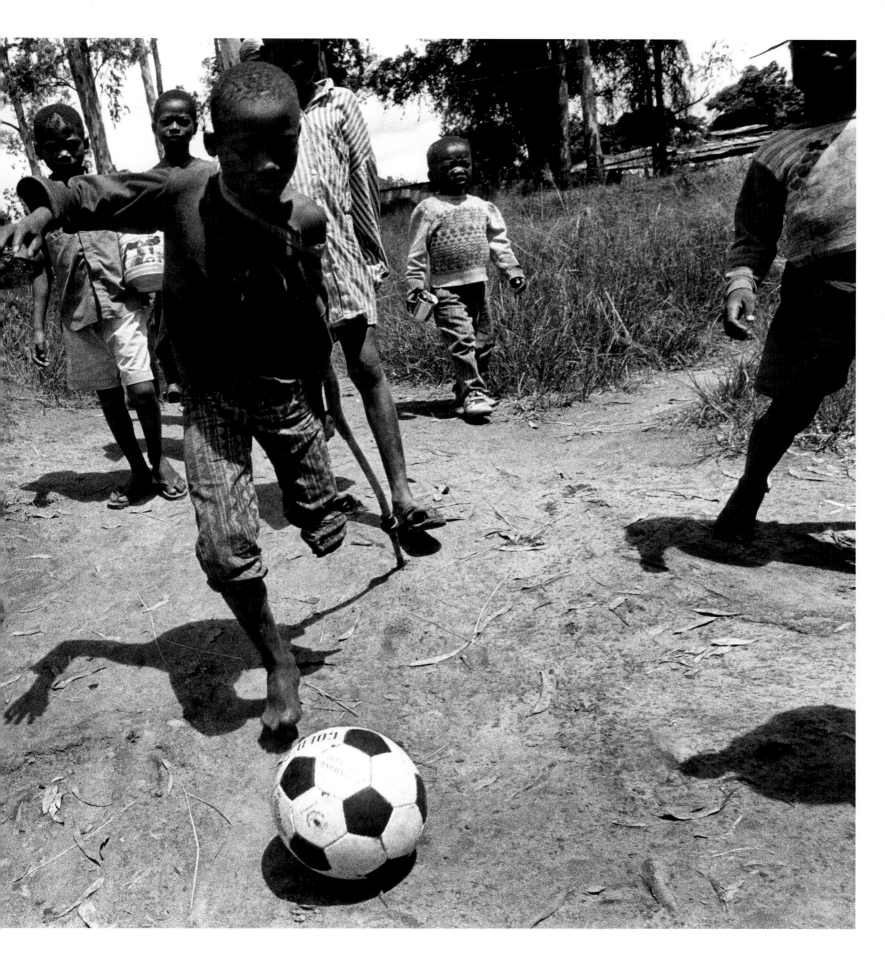

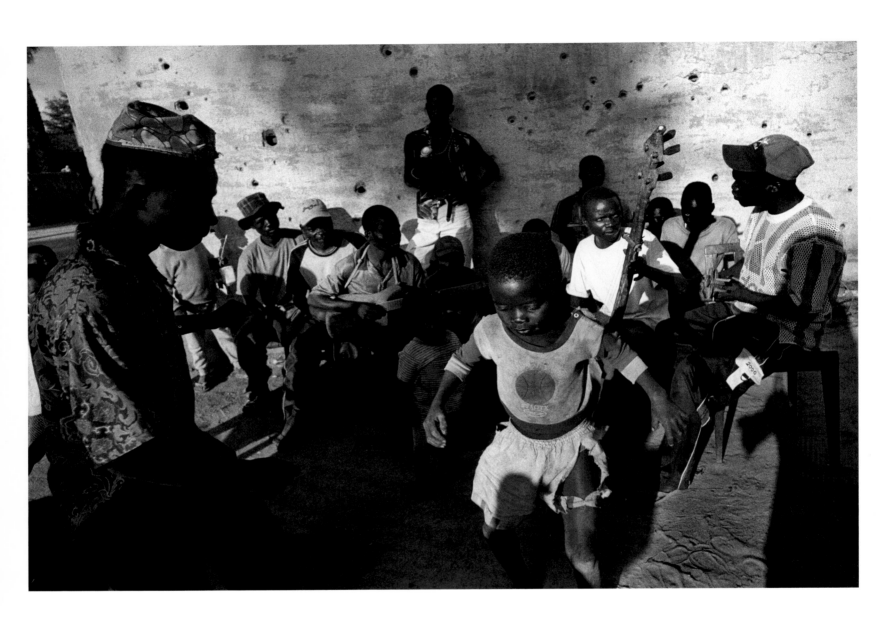

Children dance to a local band playing home-made instruments.
Luau, 2004

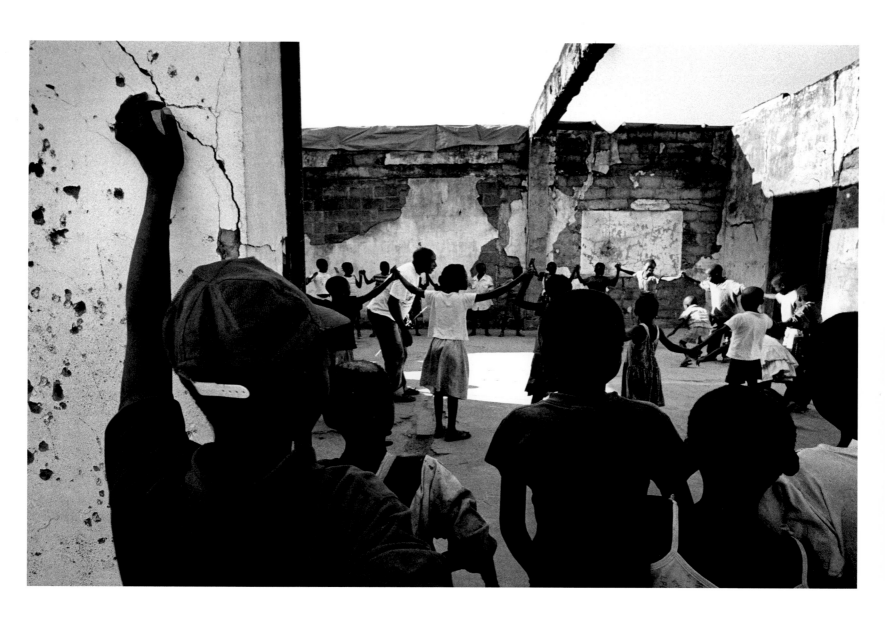

School.
Cazombo, 2004

School.
Luau, 2004

Domingus Mateus' son uncovered this mine whilst playing outside their house. Domingus reported the mine to a nearby MAG team, which took it away to be safely destroyed. Domingus said: "It's an act of God that has saved us from this mine."
Luau, 2004

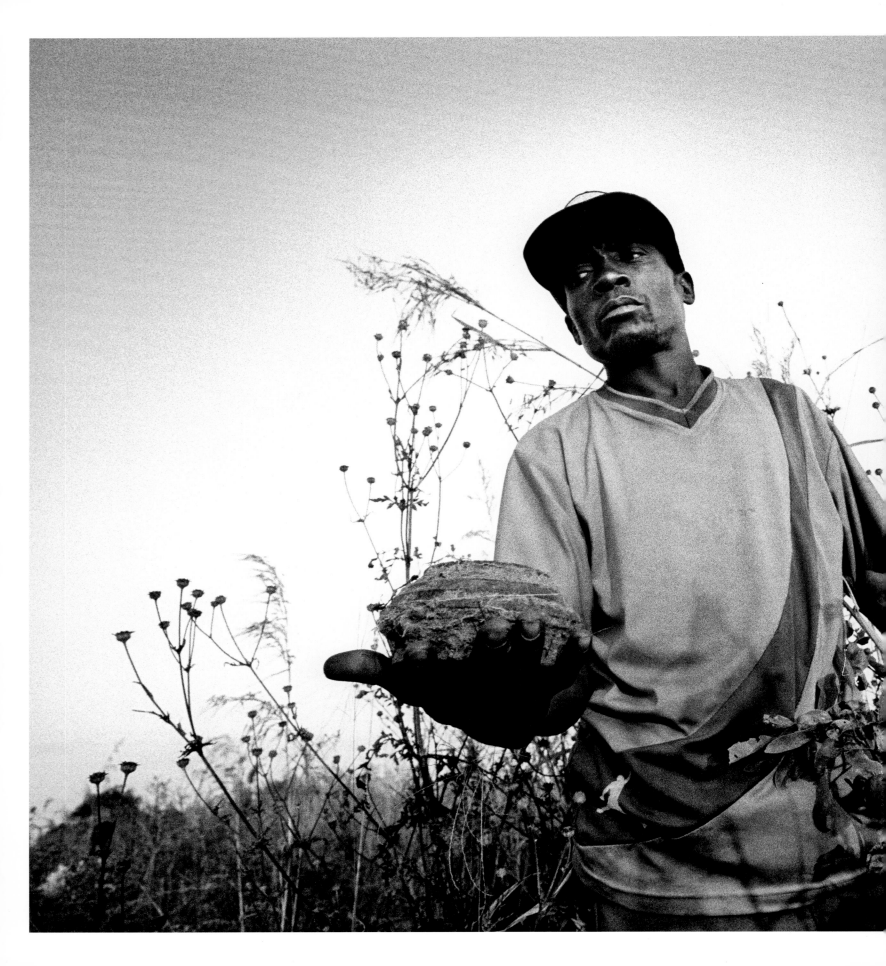

Alberto was planting cassava in his
garden when he found this landmine.
Luau, 2004

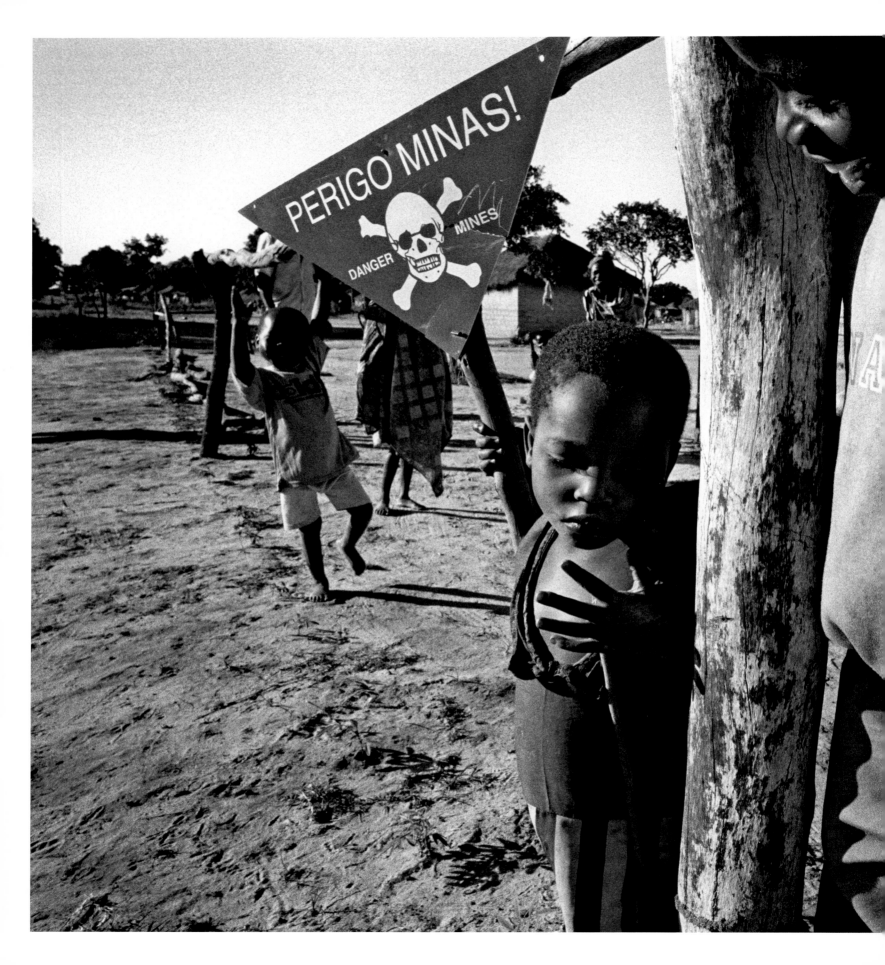

The bairro, or neighbourhood,
of Jika is a minefield.
Luau, 2004

Following pages

Left: Father and son.
Luena, 1995

Right: Fiona Sombe was looking for
firewood when she stood on a mine.
She was heavily pregnant at the time.
Fortunately she and the baby survived.
Luena, 1995

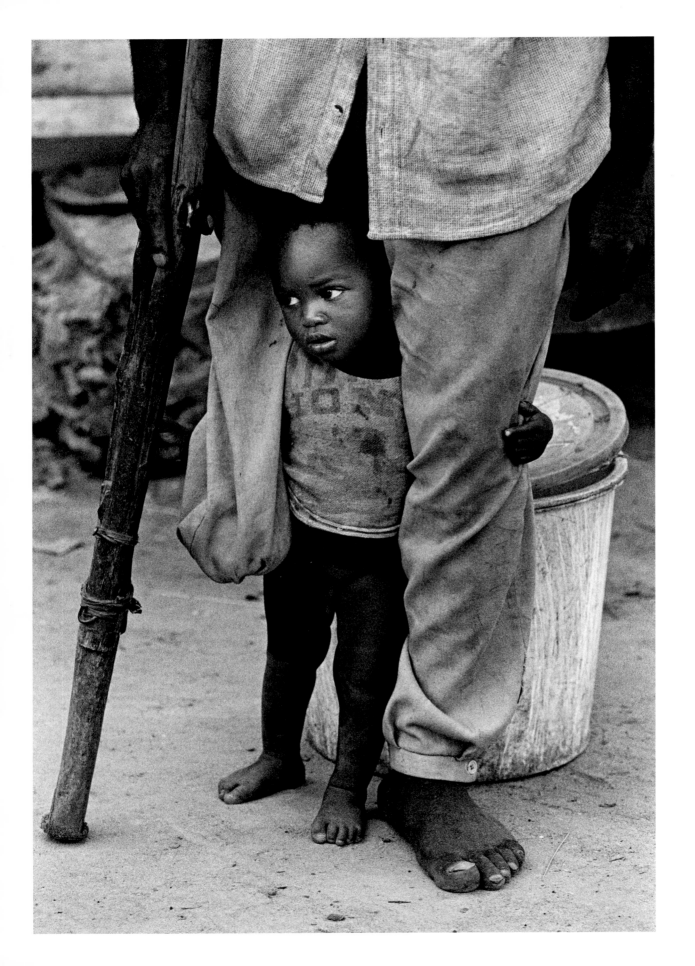

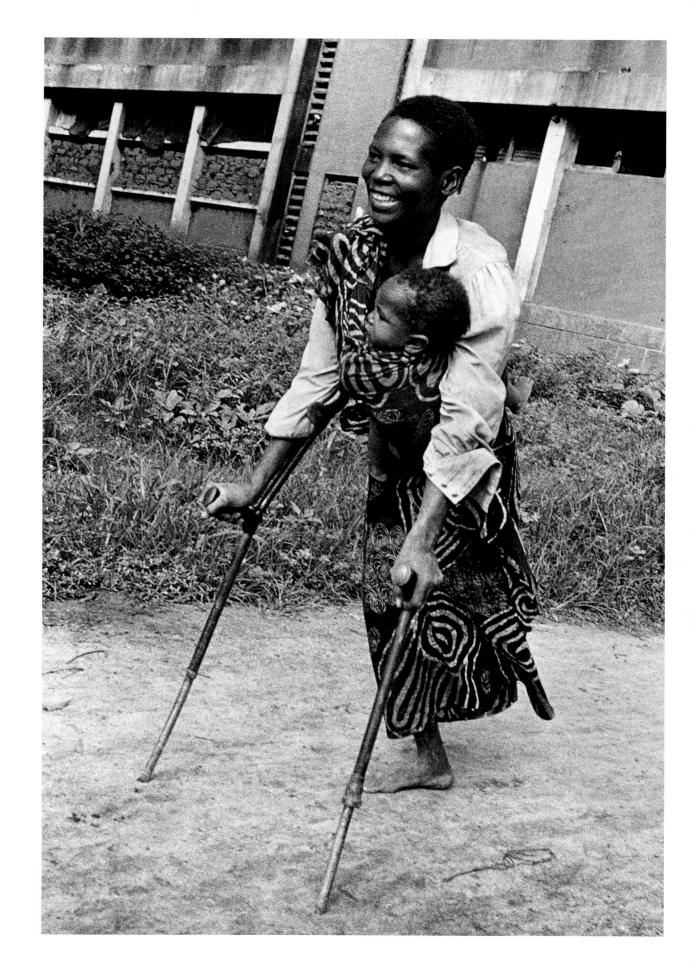

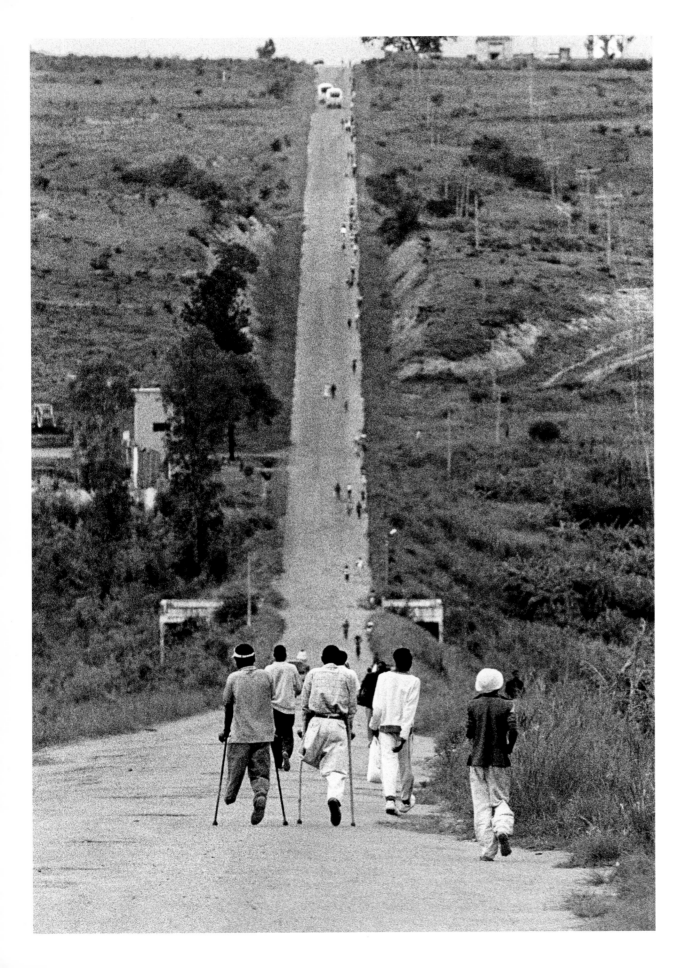

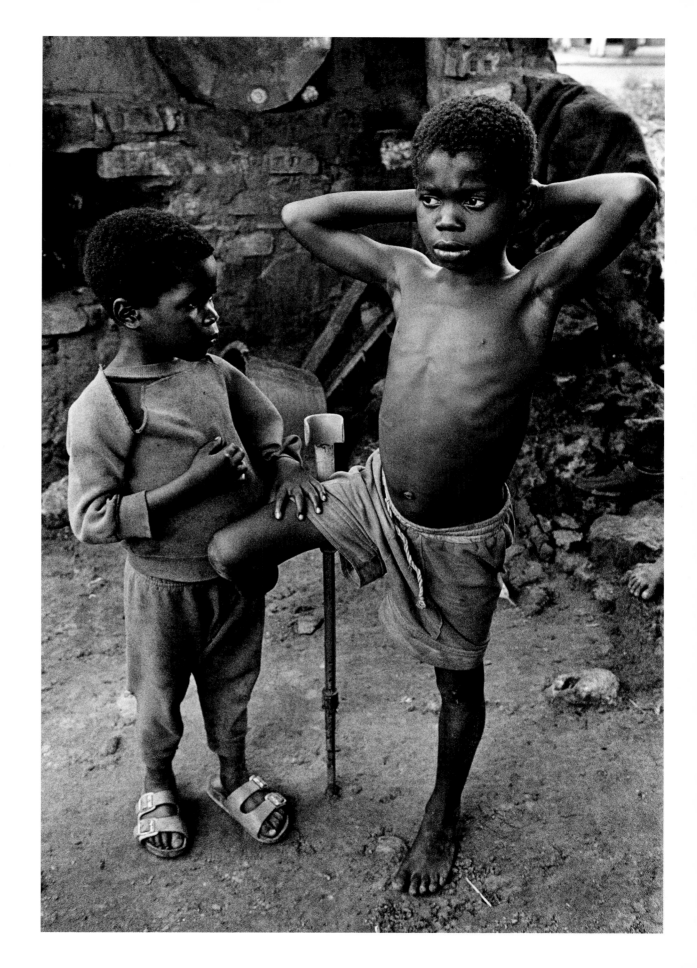

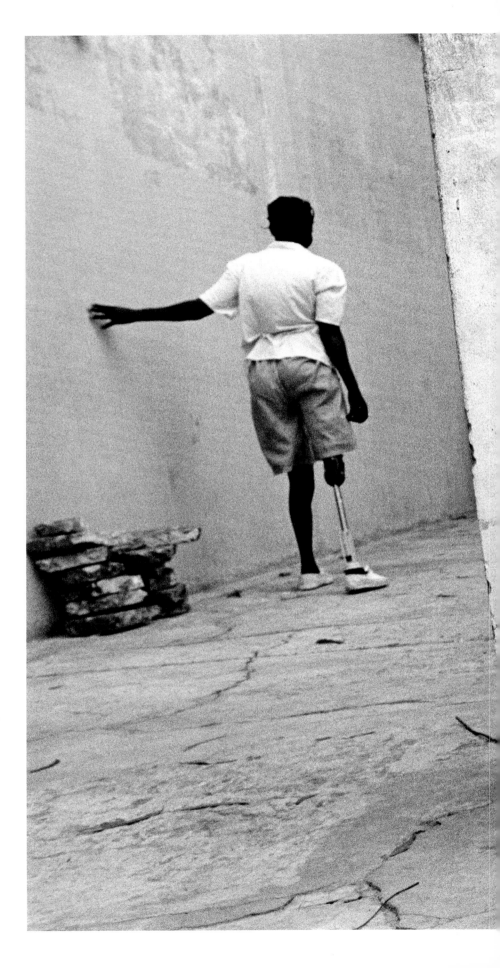

Previous pages:

Left: A long walk home.
Kuito, 1995.

Right: Many towns in Angola were surrounded by minefields denying people access to land, food and water. Edwardo nearly died after stepping on a mine. He was out collecting water with his mother.
Luena, 1997

This page: Landmine survivors at a Vietnam Veterans of America Foundation prosthesis workshop.
Luena, 2001

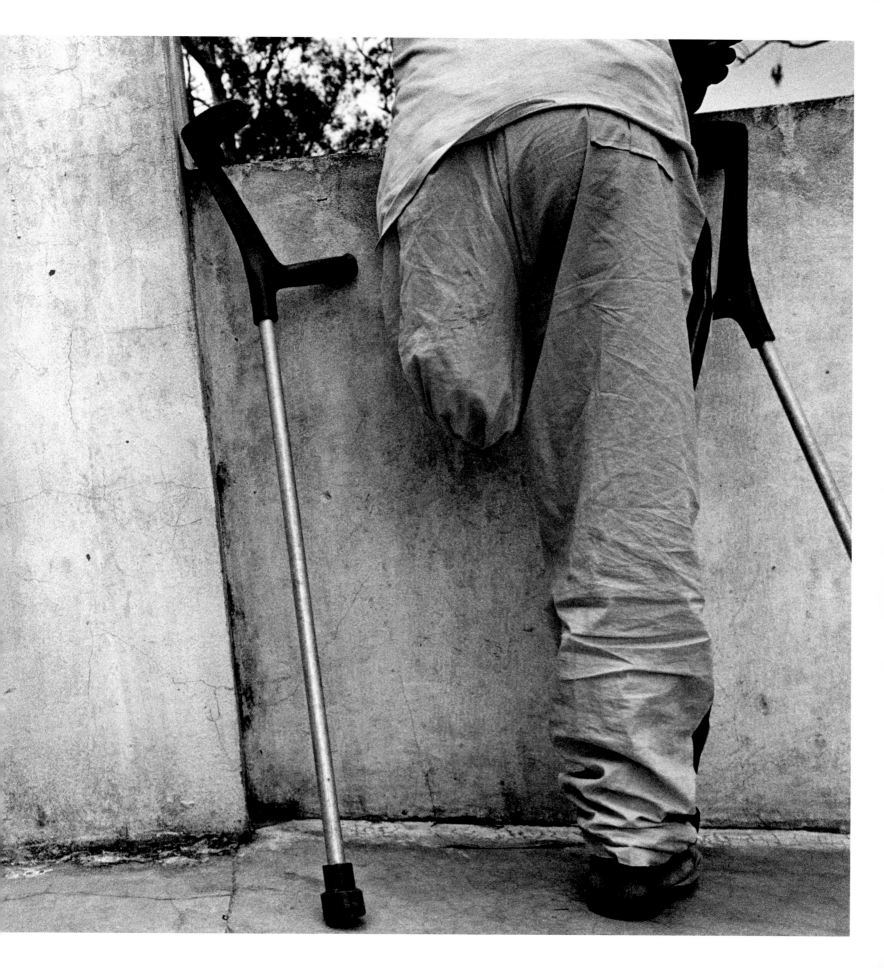

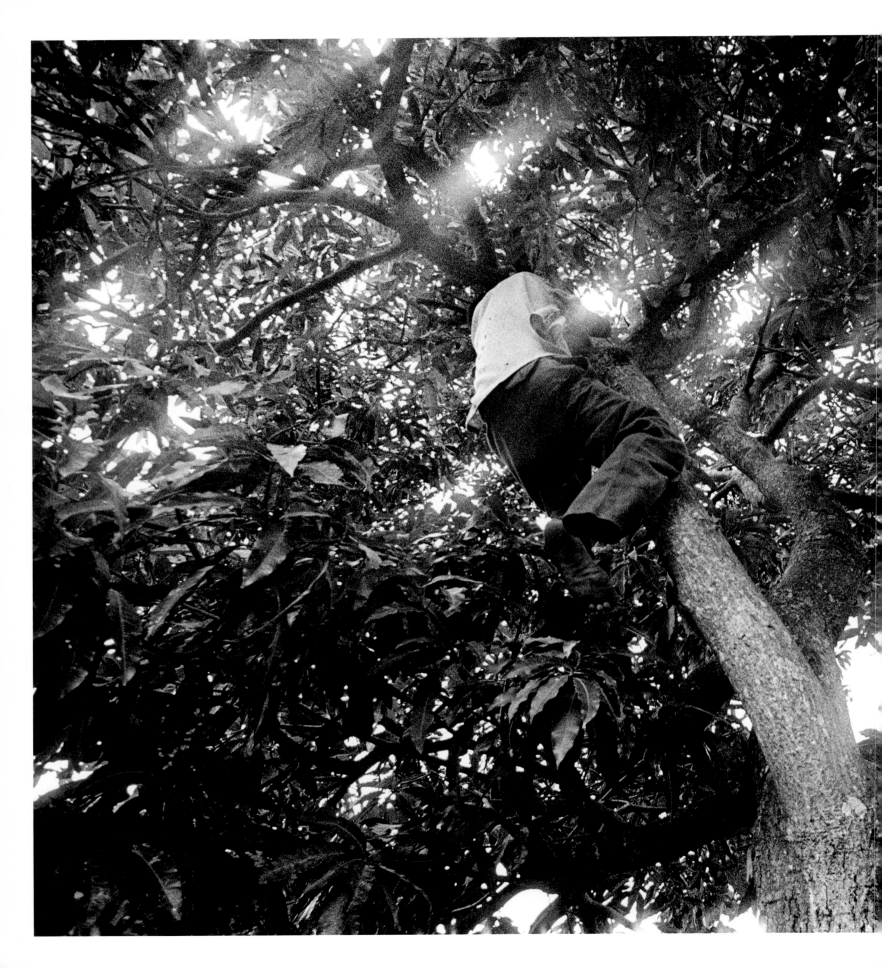

A landmine survivor climbs a
tree looking for honey.
Luena, 1997

Crossing a river near Luena. Victims
of landmines face a long and difficult
process of psychological, social and
physical rehabilitation.
Luena, 1995

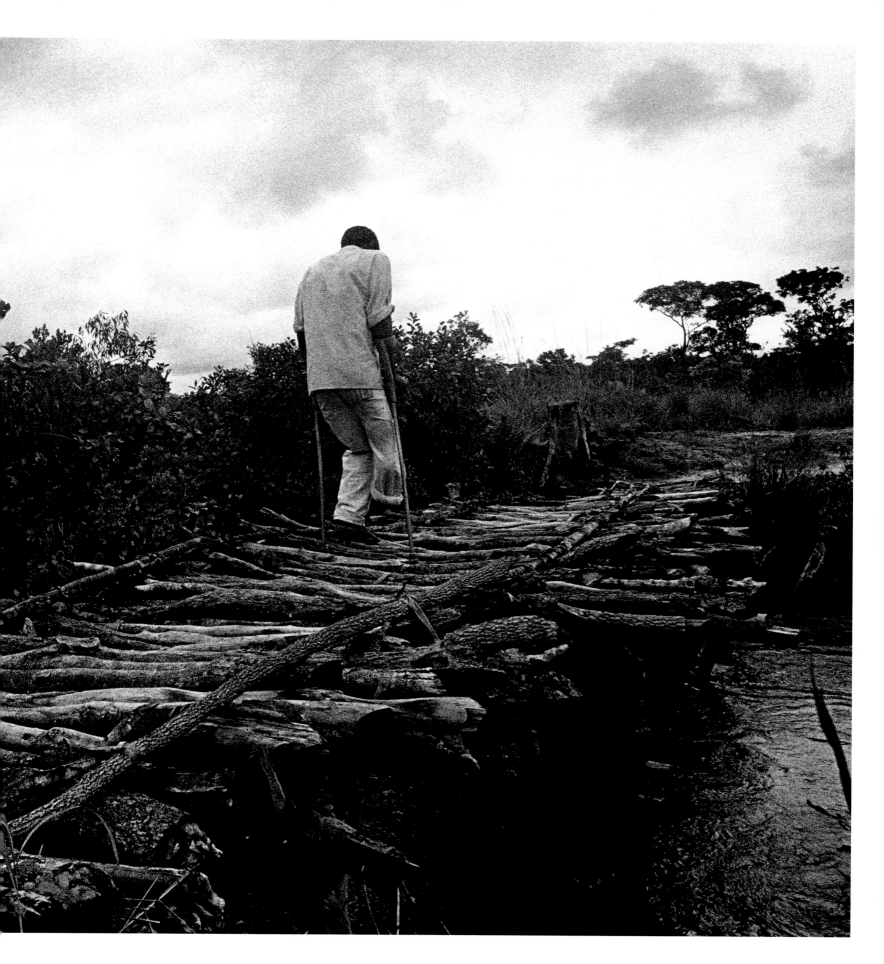

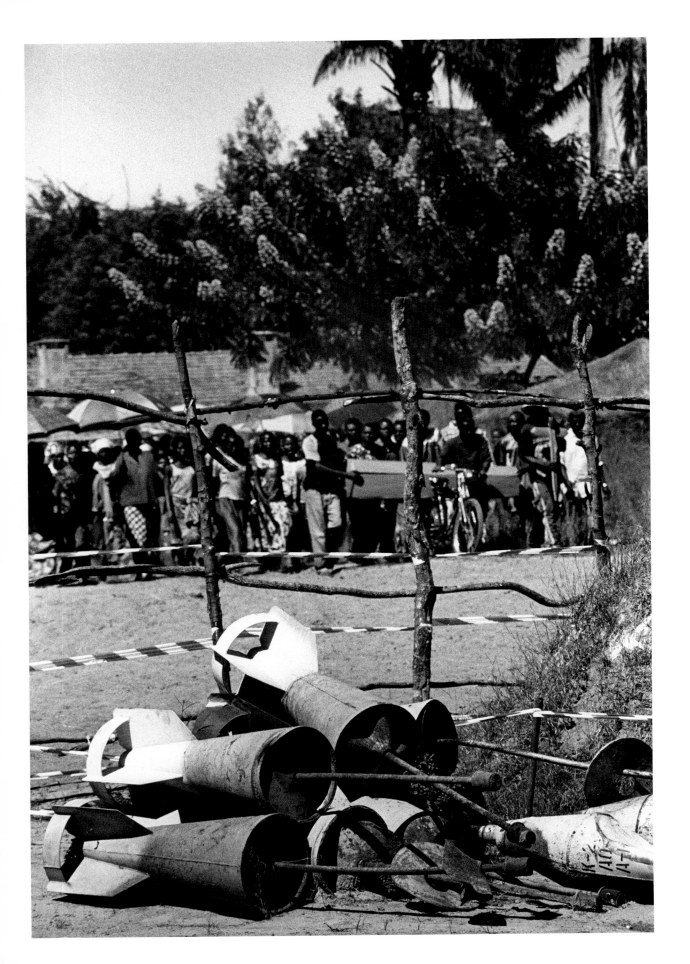

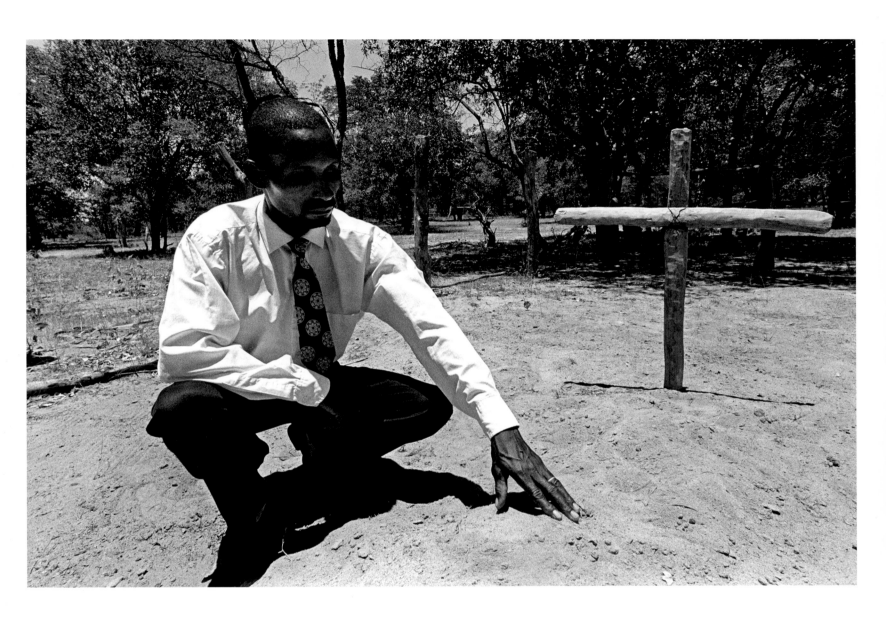

Left: Another victim. A funeral parade passes a
pile of tail units from RBK 250-275 cluster bombs.
Luau, 2004

Above: Yamba visiting his 11 year-old son's
grave before going to church. He had been killed by a
landmine two weeks before this picture was taken.
Ondjiva, 2000

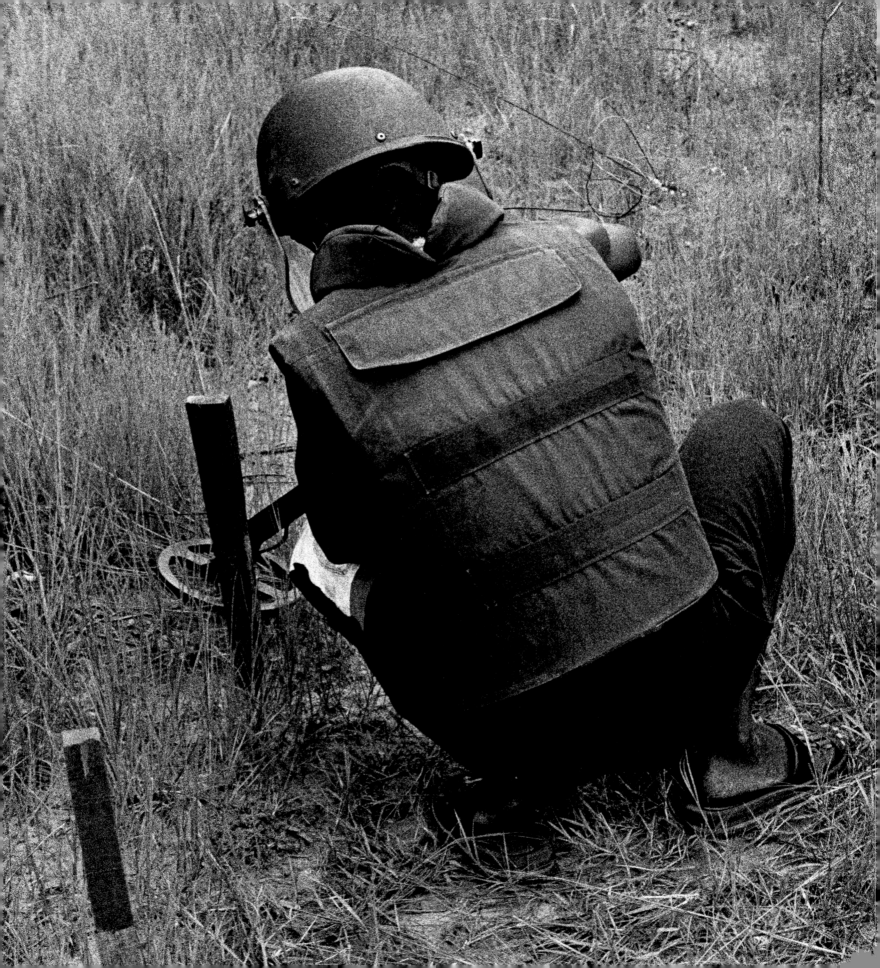

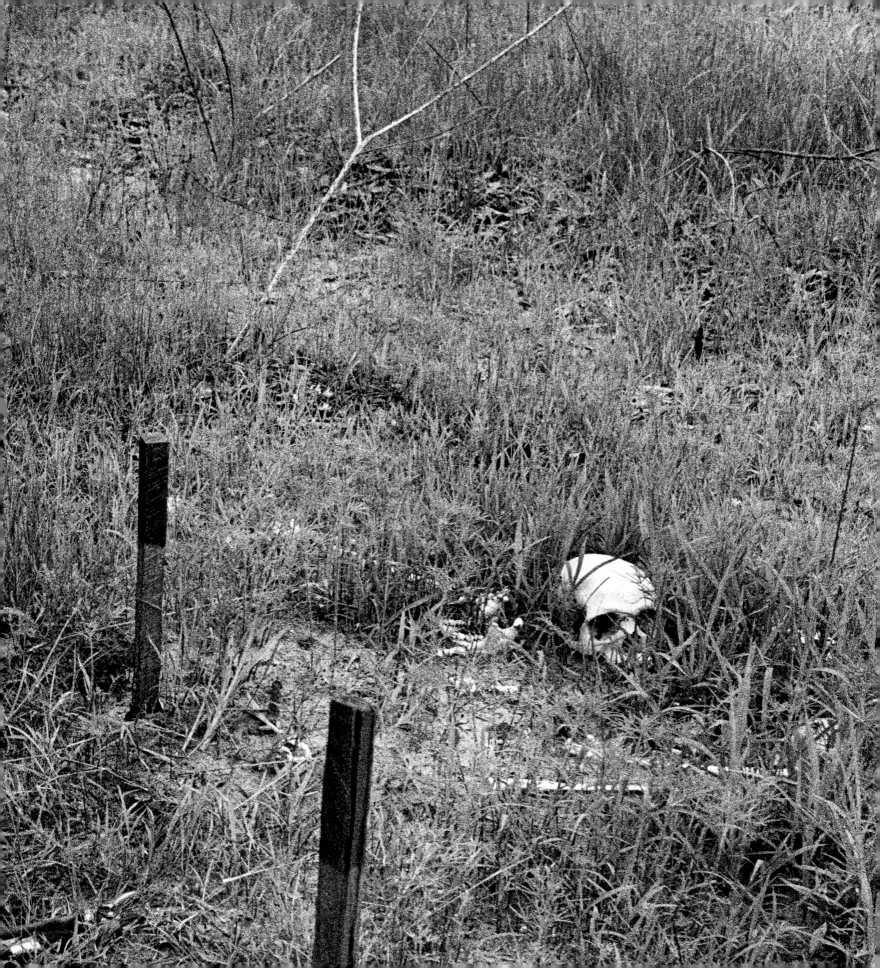

Previous page: A deminer clears
land close to the remains of a
UNITA soldier killed by a bounding
fragmentation mine. Remains of a
family — mother, father and child —
are also nearby. Bones of people
and animals often signify the
presence of landmines.
Luena, 1995

Right: A former minefield. The stick
the boy on the right is leaning on
is where MAG found and destroyed
a landmine.
Luau, 2004

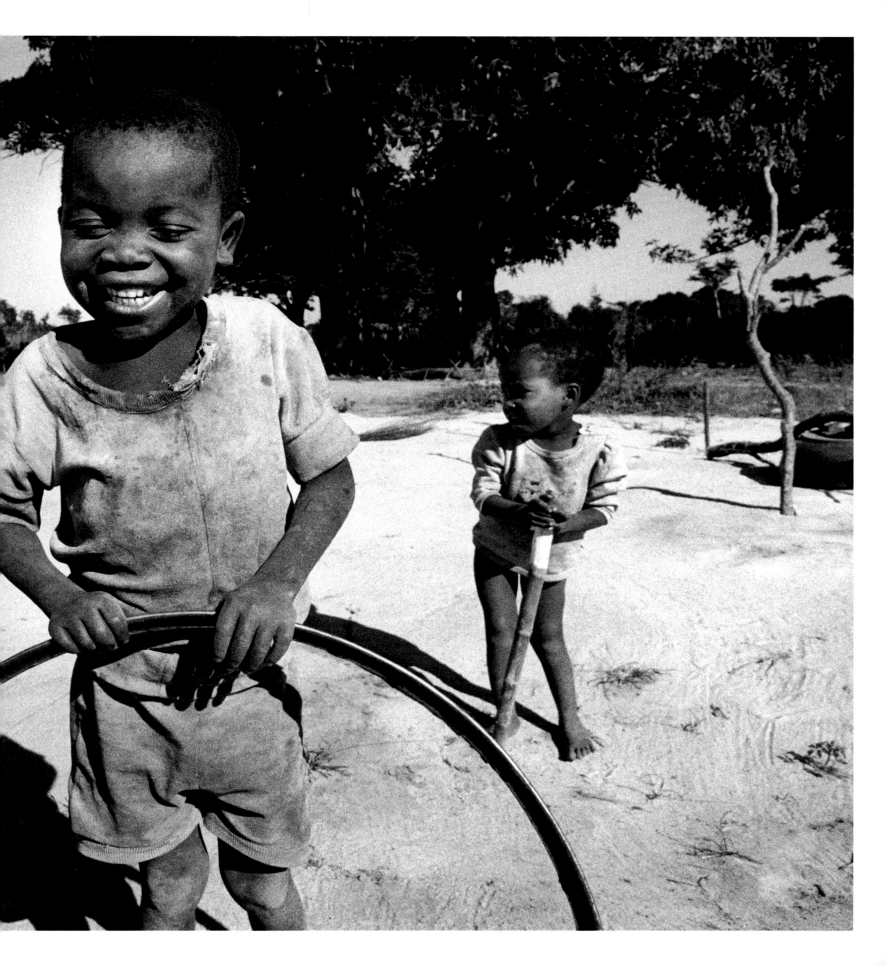

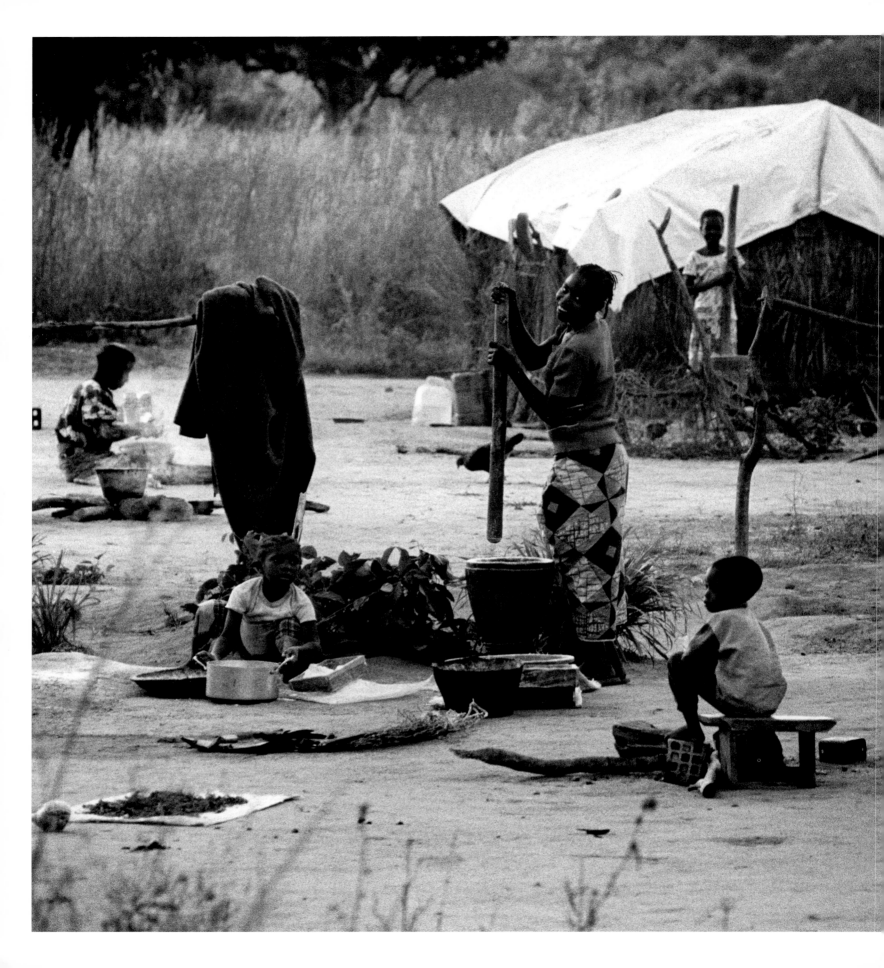

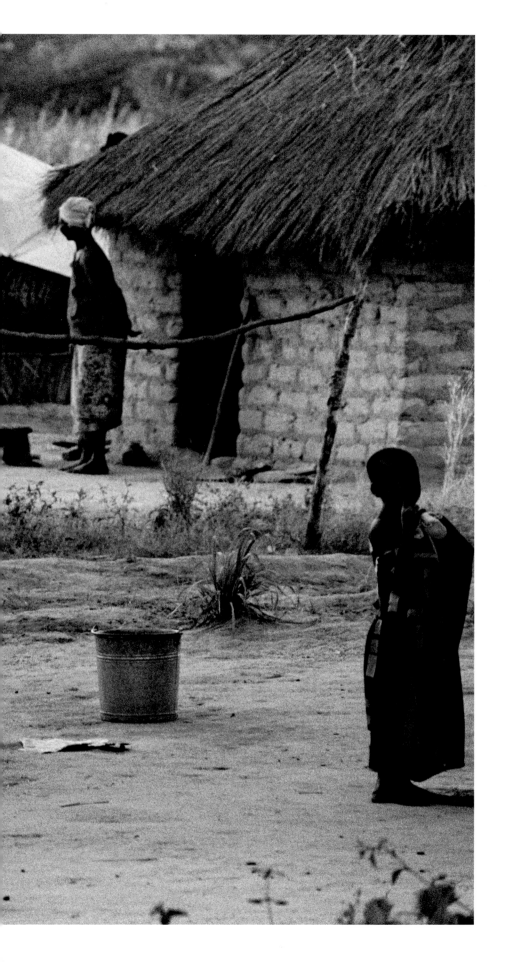

Although the conditions
are hard, people are happy to
be home. Many have lived as
refugees in bordering countries
for more than 25 years.
Luau, 2004

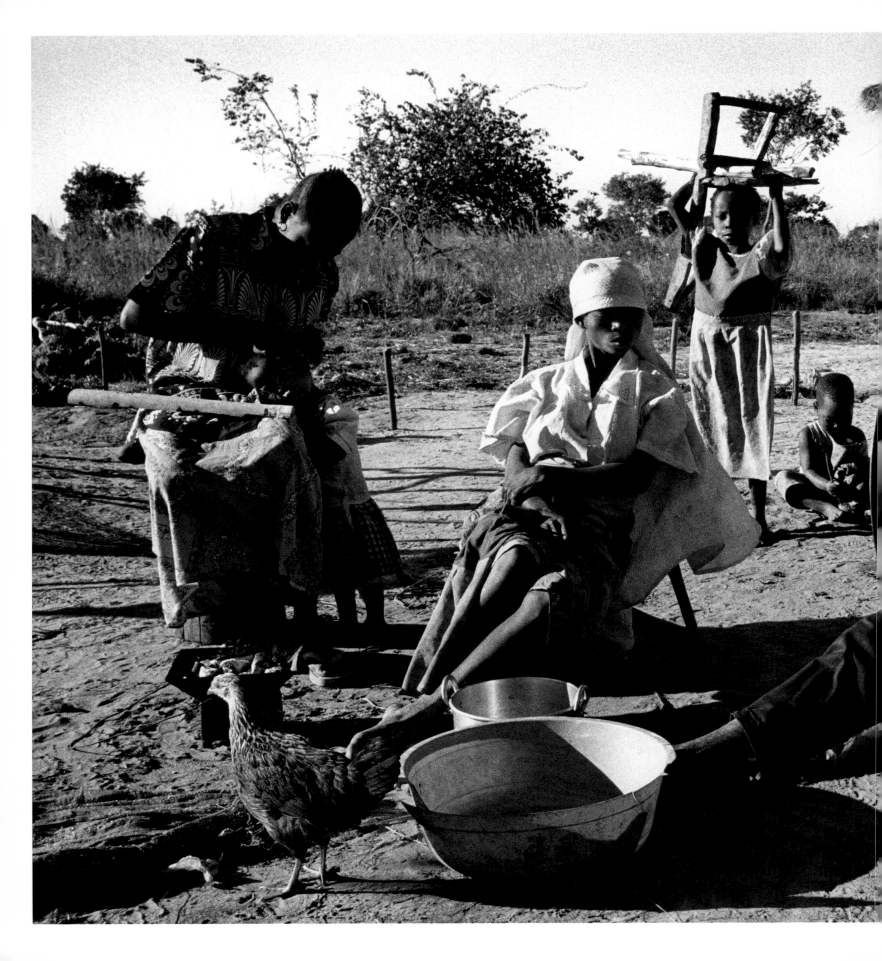

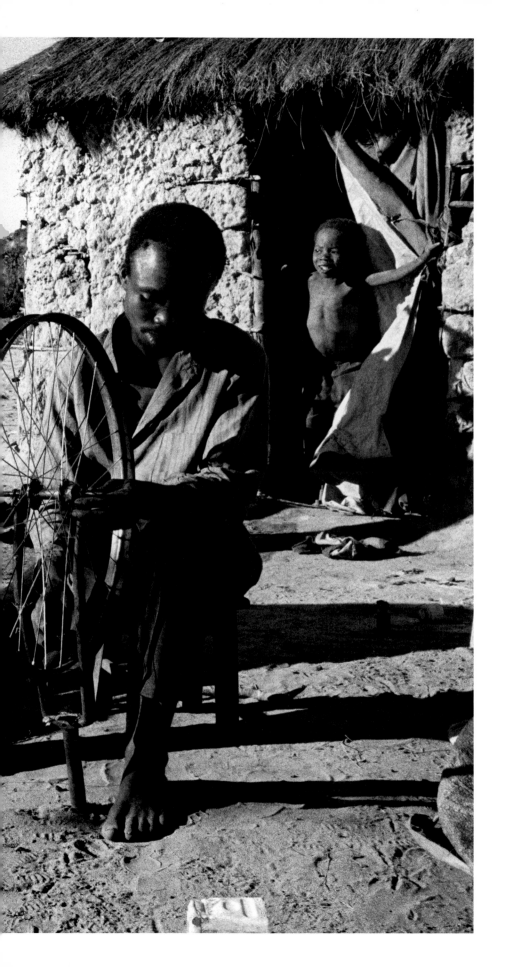

Chivanda arrived recently with his family from neighbouring Congo: "I had no idea this area was mined. When I started building this house I dug up two mines. I was so scared but there was nowhere else we could go." MAG teams cleared around the house and found four mines. "We are very thankful that it is now safe," said Chivanda. "The deminers are still working close by and soon it will all be safe."
Luau, 2004

Following pages:
Children running down a path. On both sides there are known minefields.
Luau, 2004

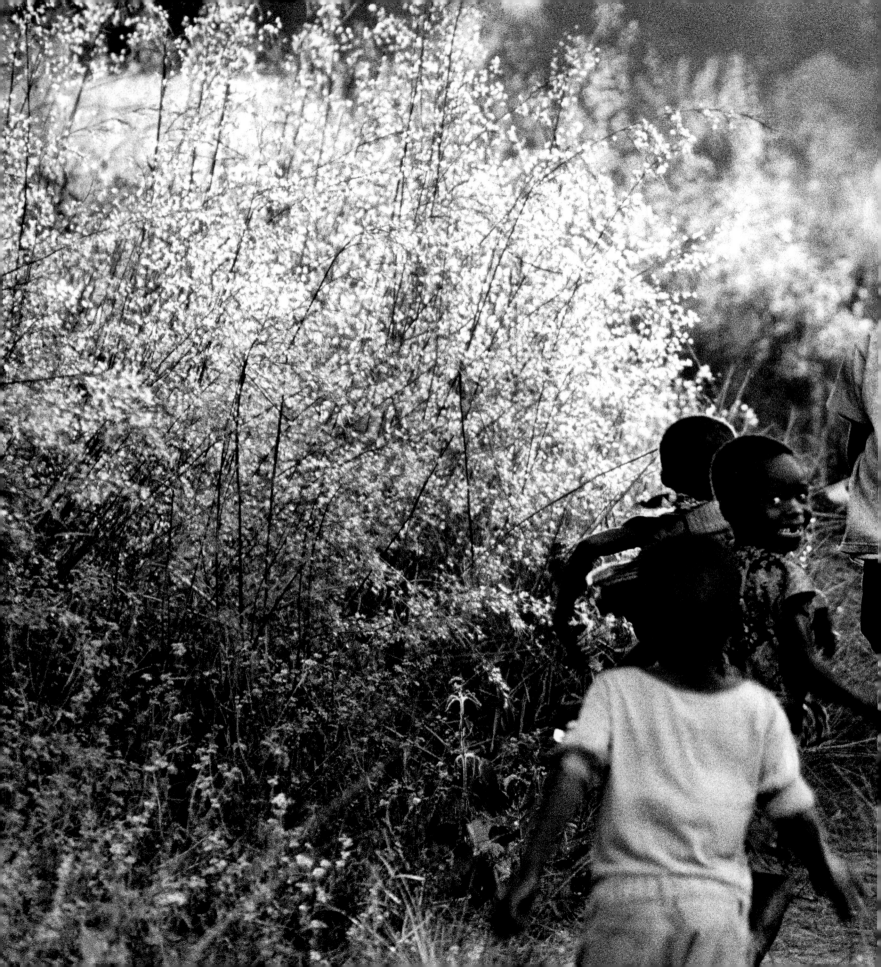

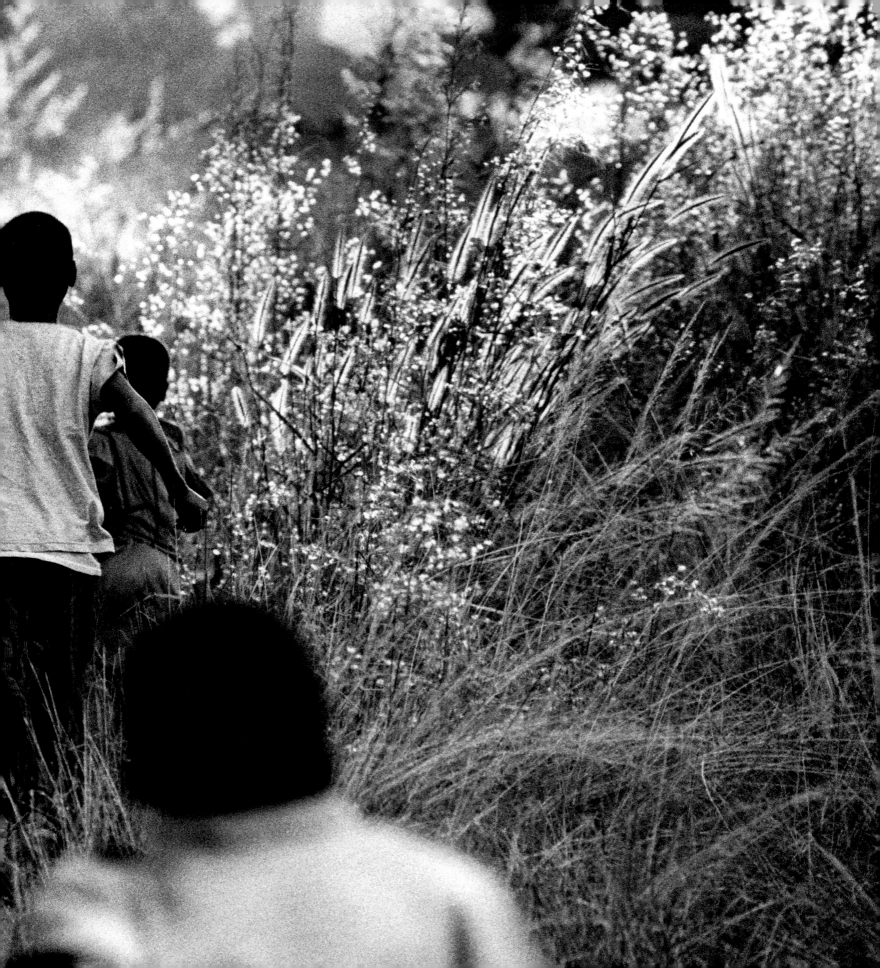

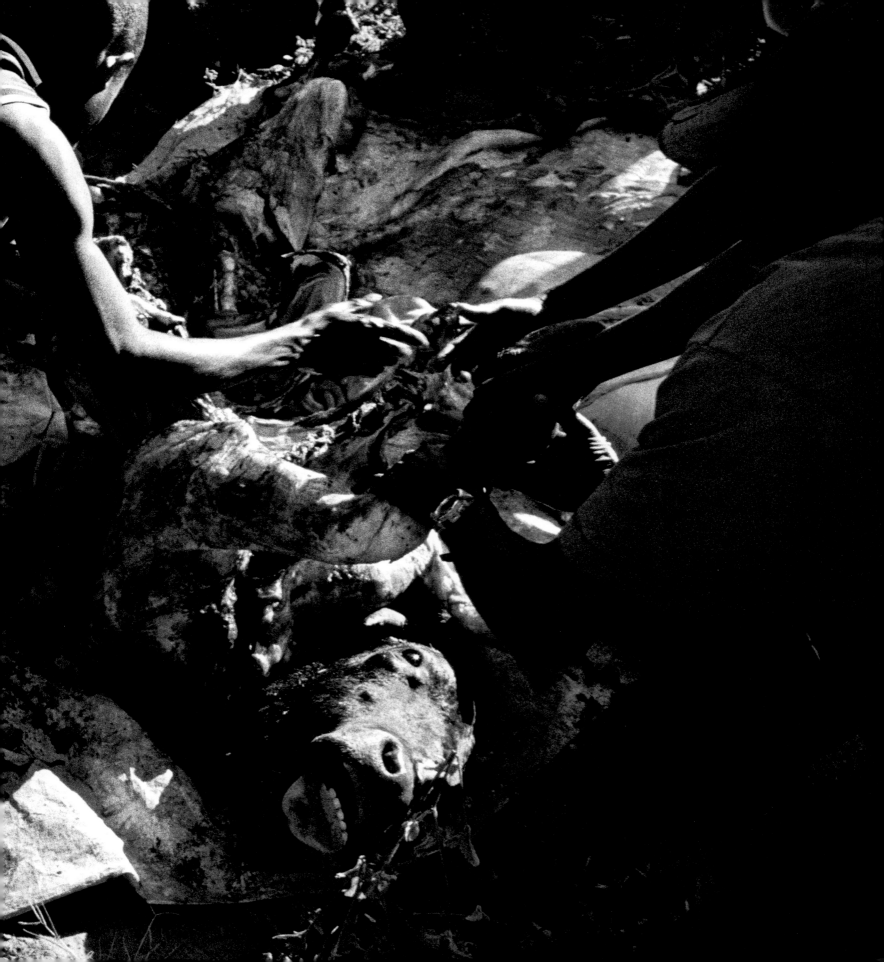

Previous pages: The first cow to be slaughtered in Luau for many years. This animal was brought over from bordering Congo.
Luau, 2004

Right: Some of the cow ends up in the market.

Following pages:

Left: A witch doctor or chimbanda.

Right: This woman was a dancer with a chimbanda many years ago. She said the markings on her face made her beautiful.
Luau, 2004

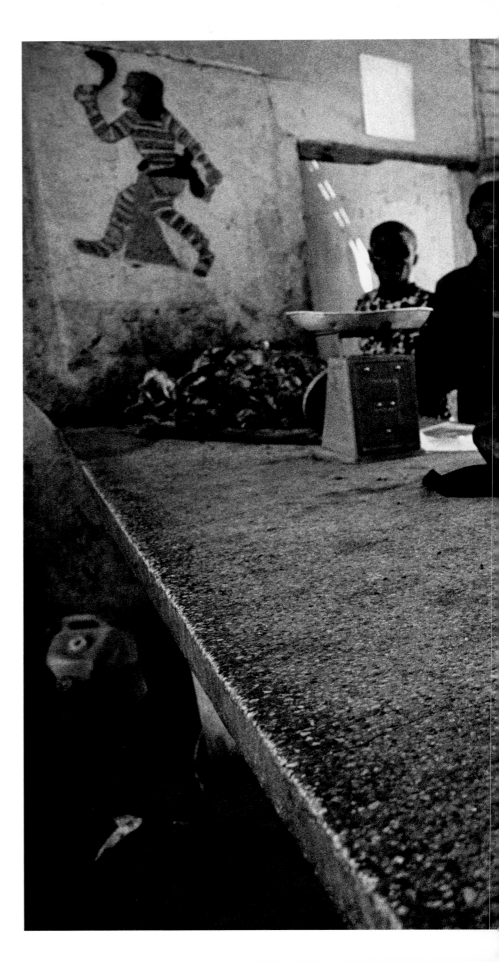

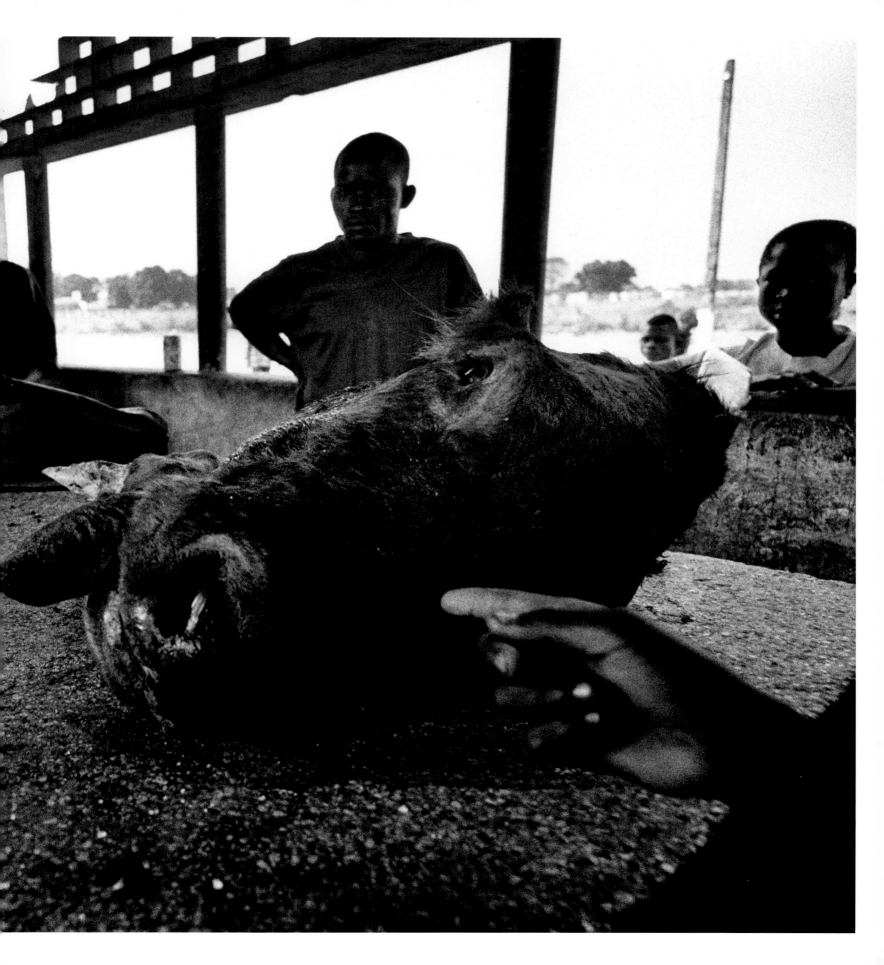

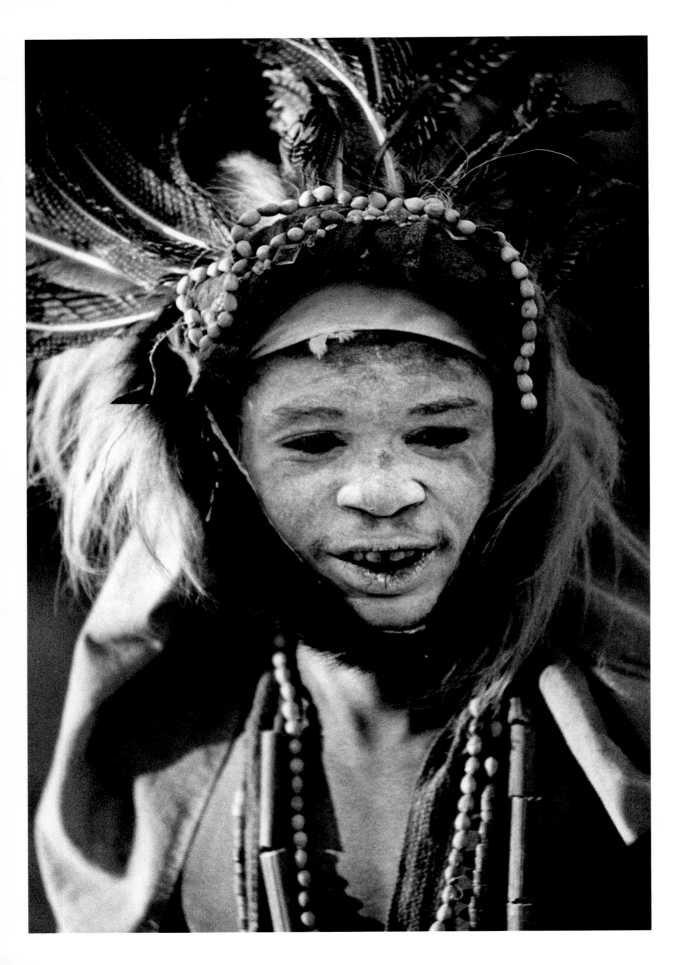

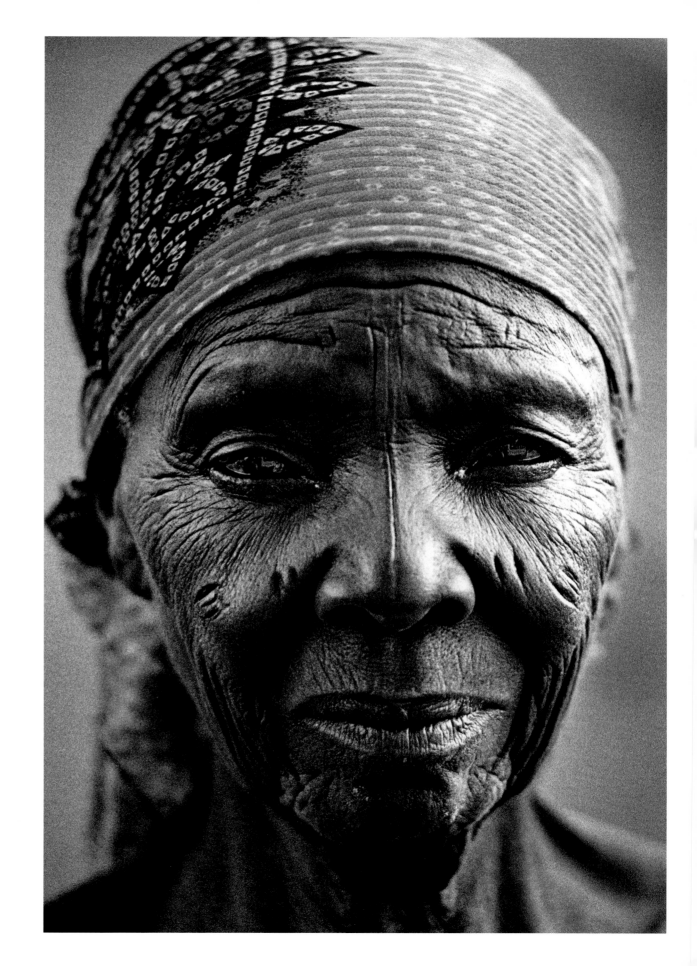

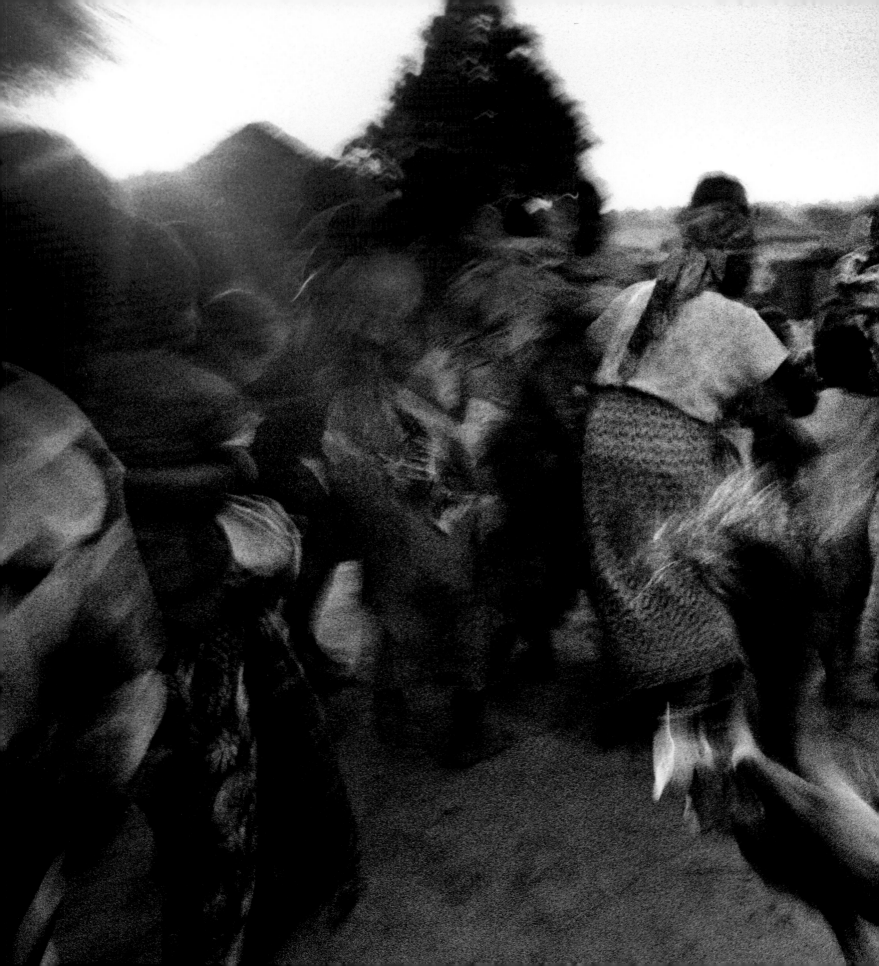

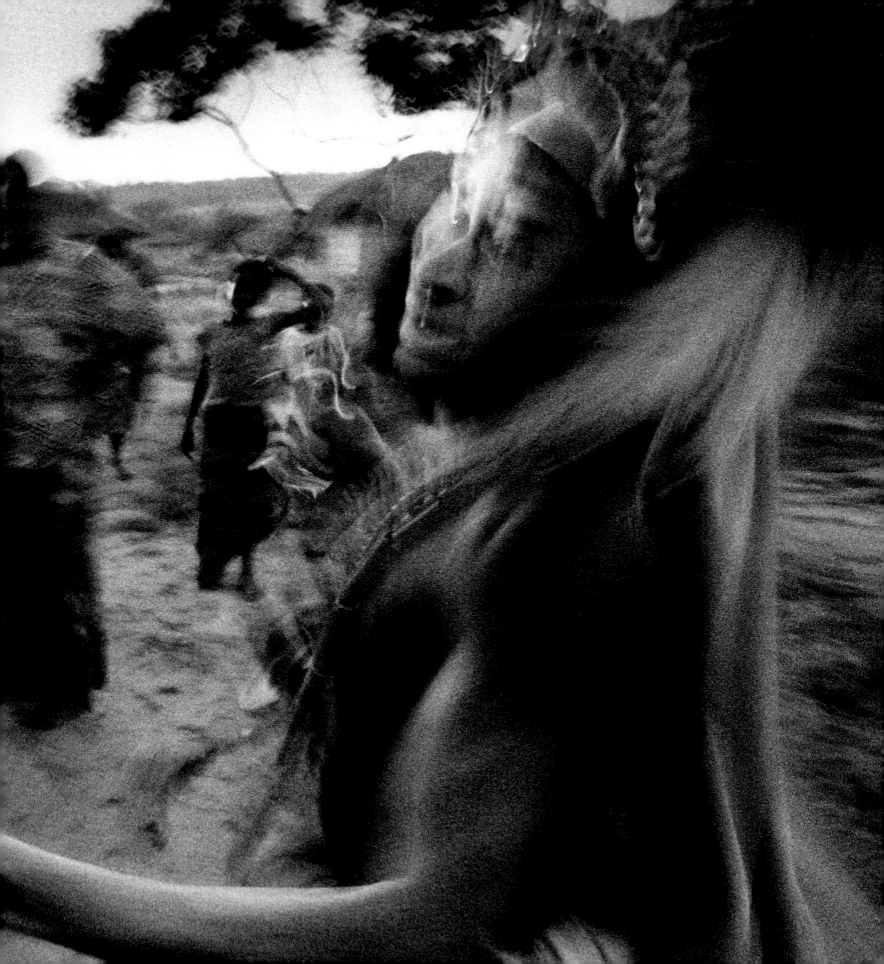

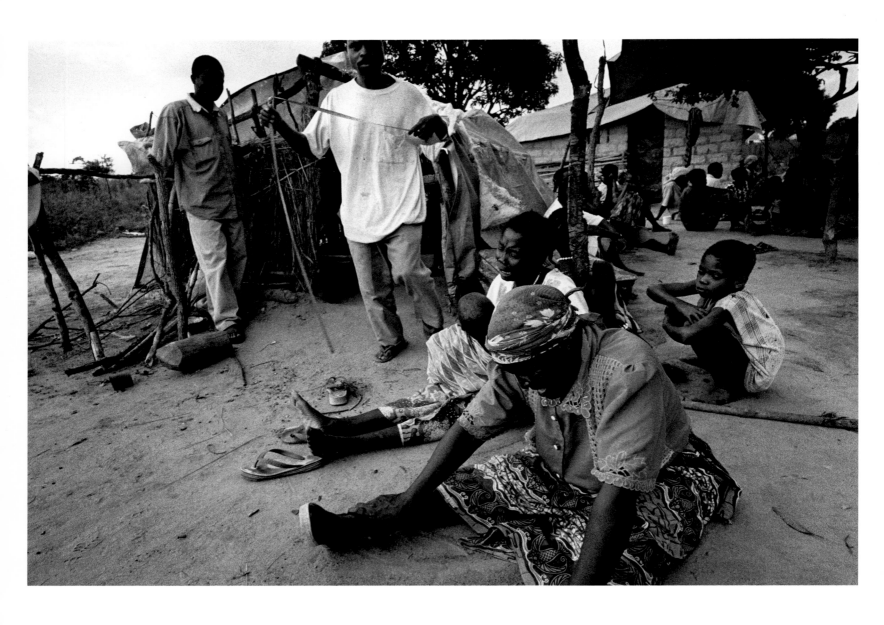

Previous pages: A chimbanda runs through a village to scare
away the bad spirits.
Luau, 2004

Above: People grieve after the death of a man reportedly cursed
by a witch doctor. The dead man's brother, James Campuba, has just
measured the body for the coffin.
Luau, 2004

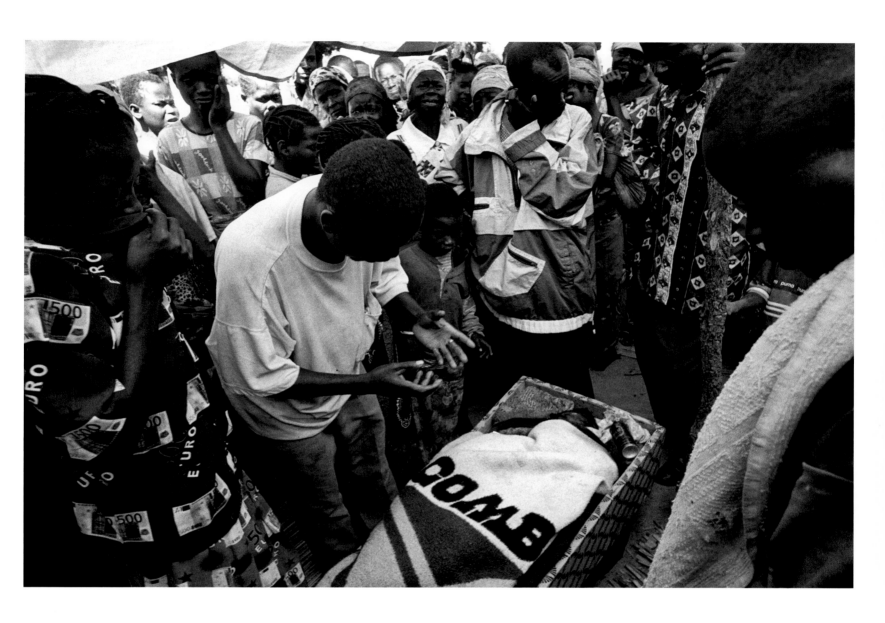

James grieves over his brother's body. He will
now have to care for eight more children. "With no
job and no money, how can I do it?"
Luau, 2004

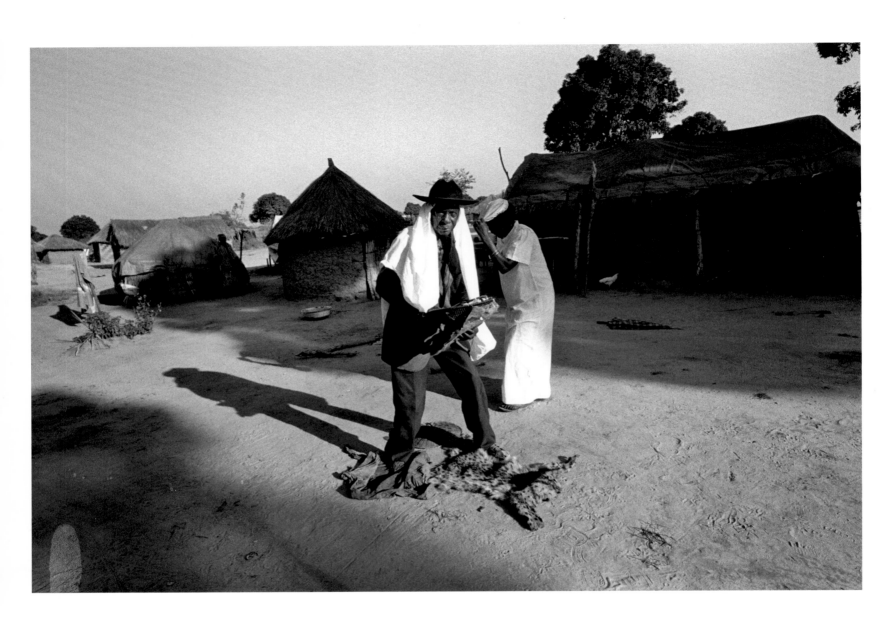

Kashama Samuchinda is also a chimbanda. He is particularly good
at helping people with mental illness and epilepsy. He doesn't know
how old he is: "I remember the year 1920 because that's when they
started building the railway. I was a man then."
Luau, 2004

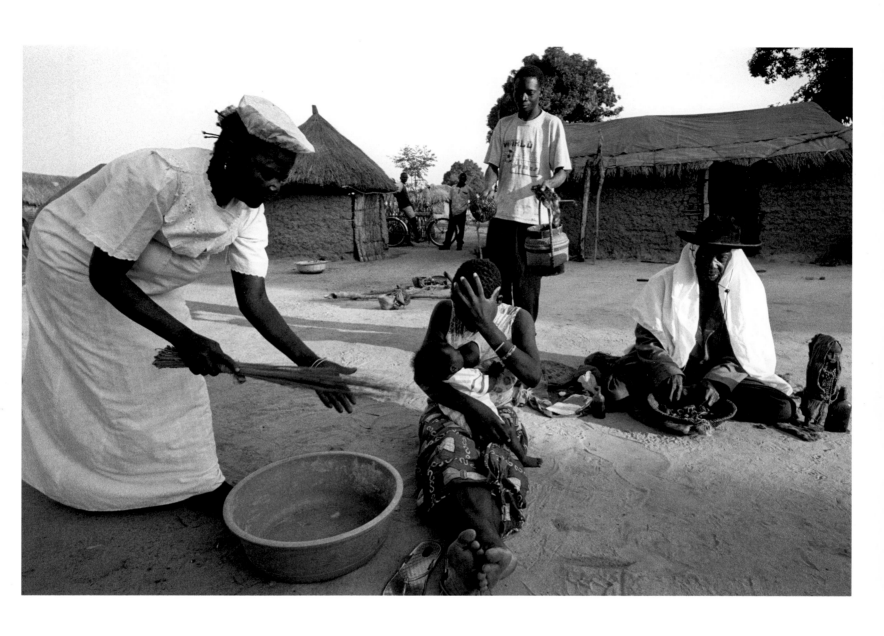

Kashama, with assistance from his wife and son,
treats Maria who has difficulty lactating.
Luau, 2004

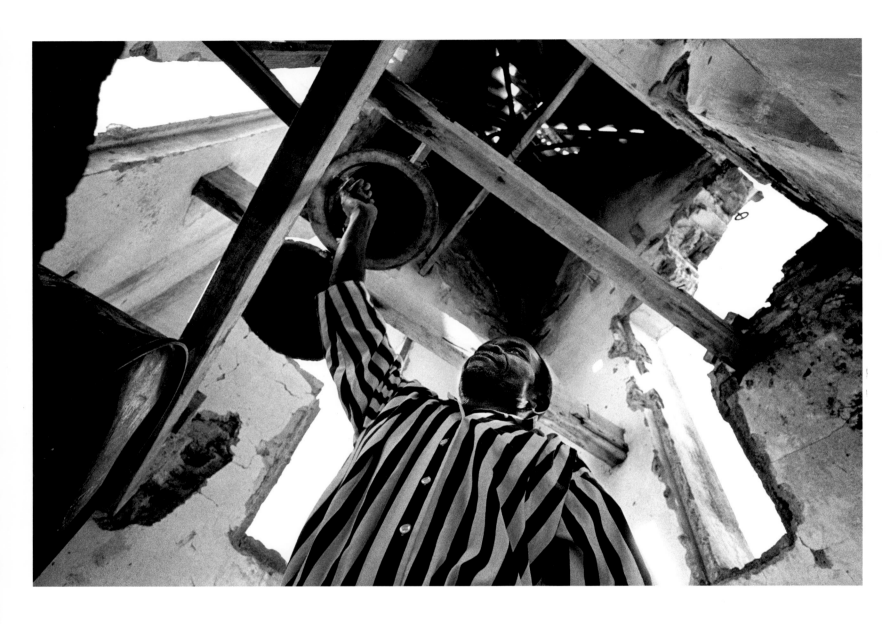

Like all buildings in Luau, the Catholic Church was badly damaged
by the war. The bell tower was hit by numerous shells and rockets
and is particularly precarious.
Luau, 2004

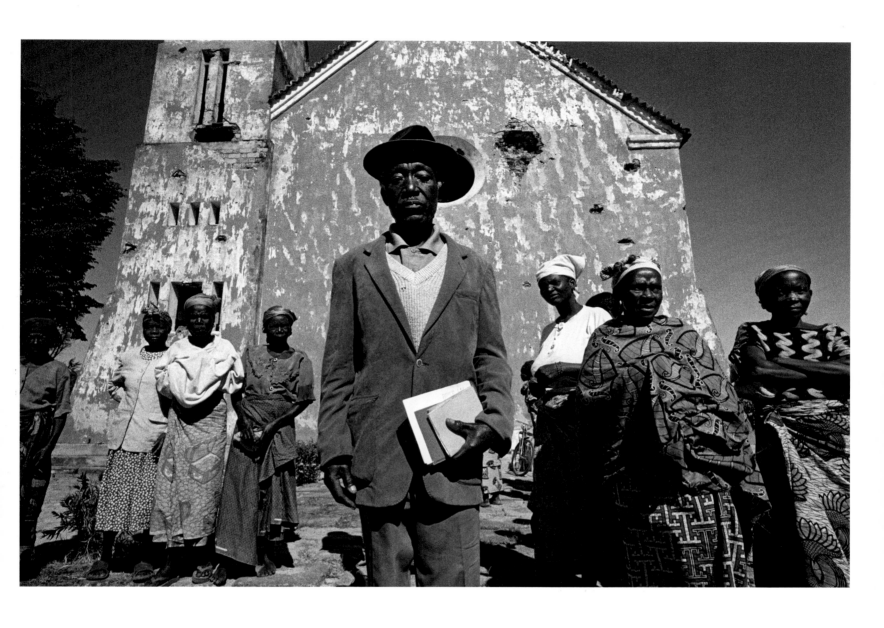

Pierre Mujinga, priest of Luau Catholic Church, with
some of his congregation. "At last there is peace
here and people are coming home."
Luau, 2004

The wedding of Viera Lukas Martinho
and Flora Cassinda.
Luau, 2004

An MSF nurse weighs four month old
Adelina, who is in a serious condition
with malaria and pneumonia.
Luau, 2004

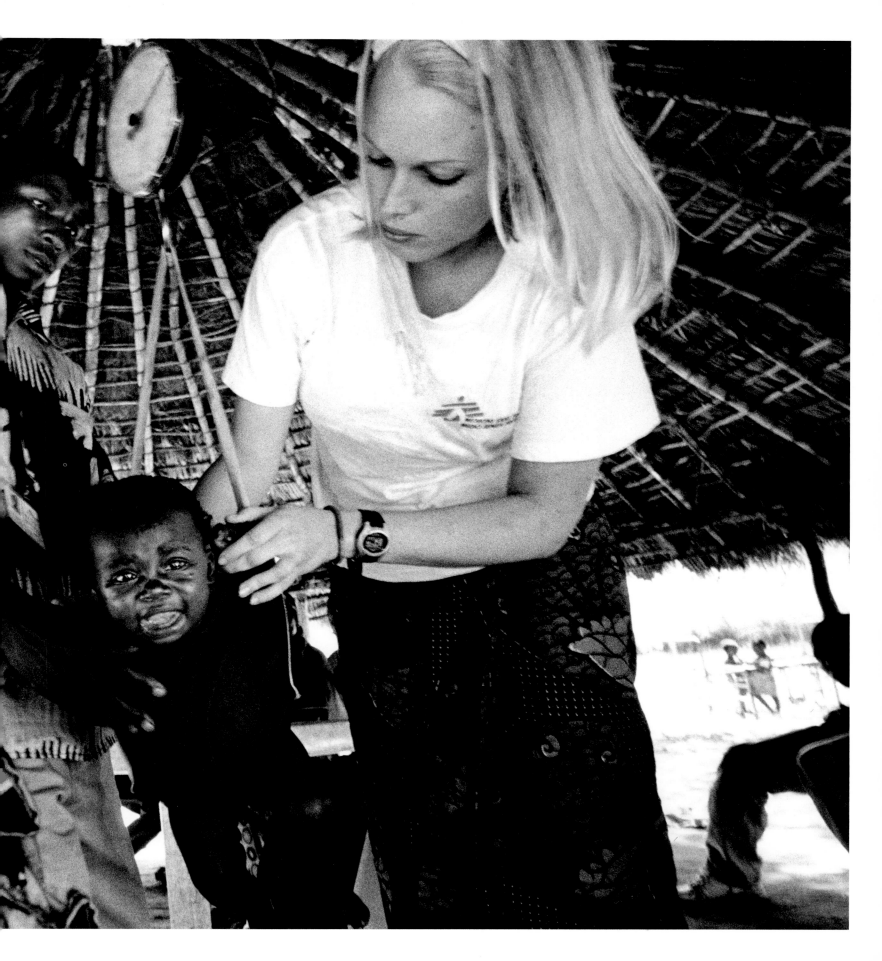

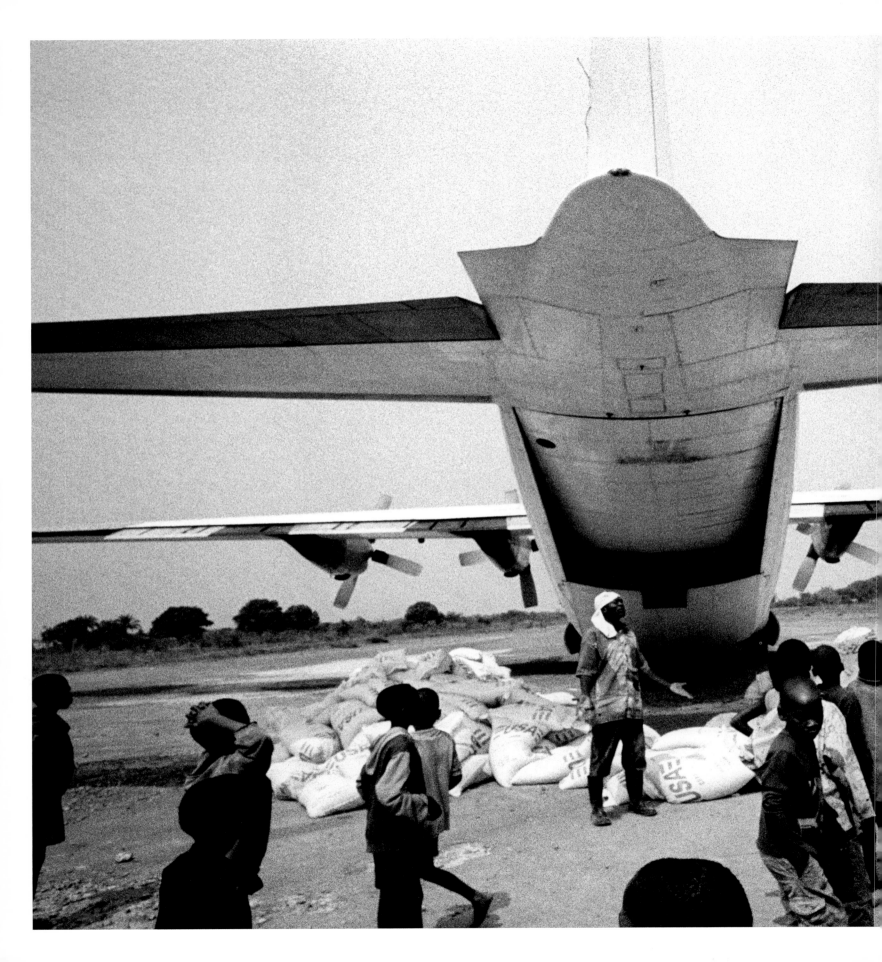

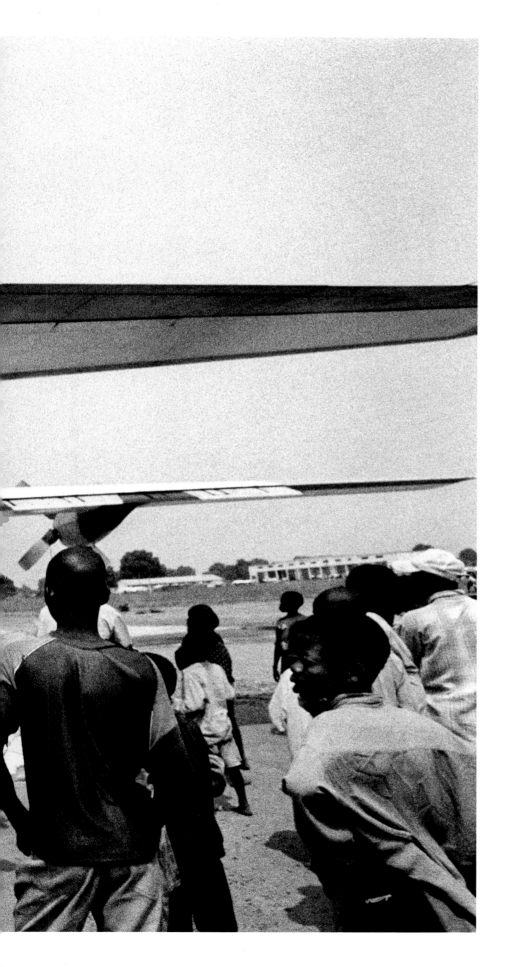

A labourer appeals to children to stop
looting aid delivered by a UN Hercules.
Luau, 2004

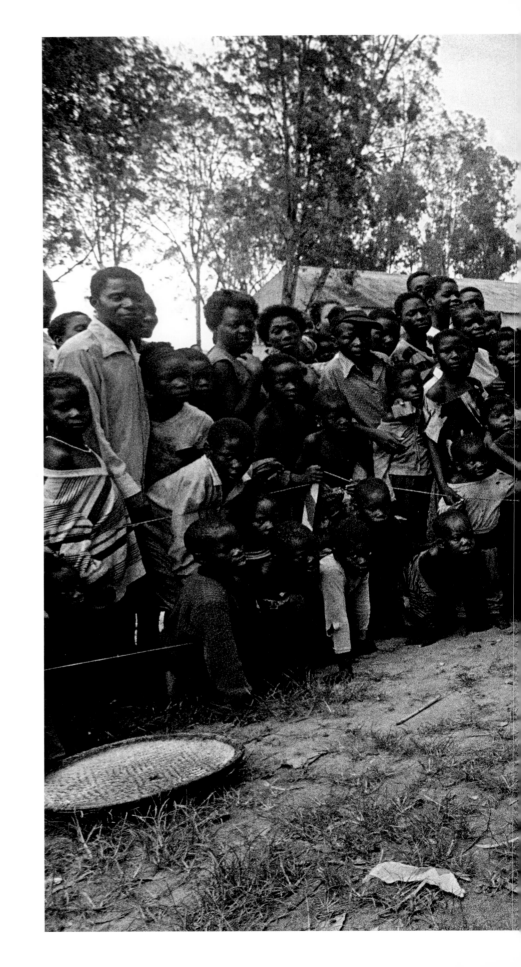

MAG mine risk education staff
demonstrate how to retrieve
a mine victim.
Luena, 1995

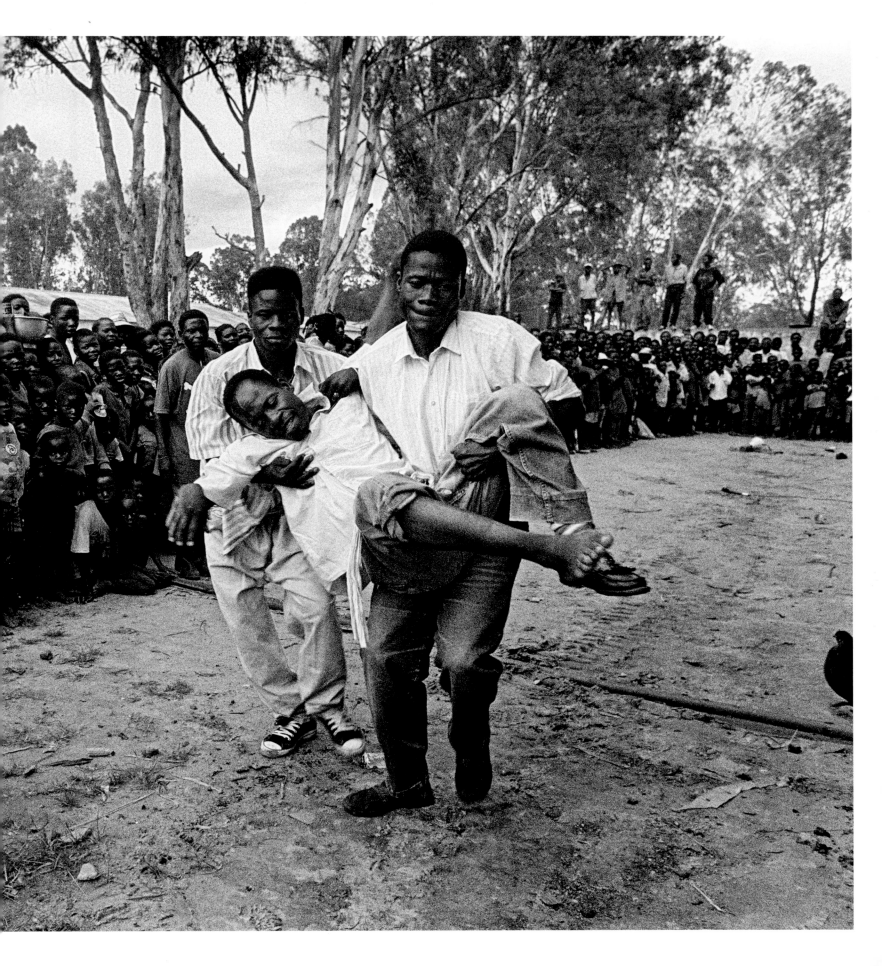

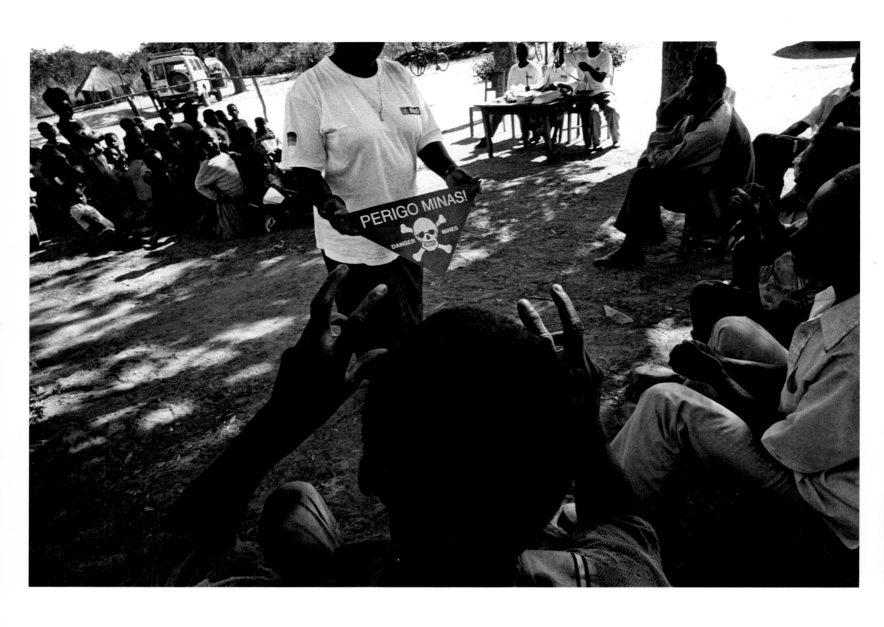

During a mine risk education session a man
describes how his friend was blown up.
Cazombo, 2004

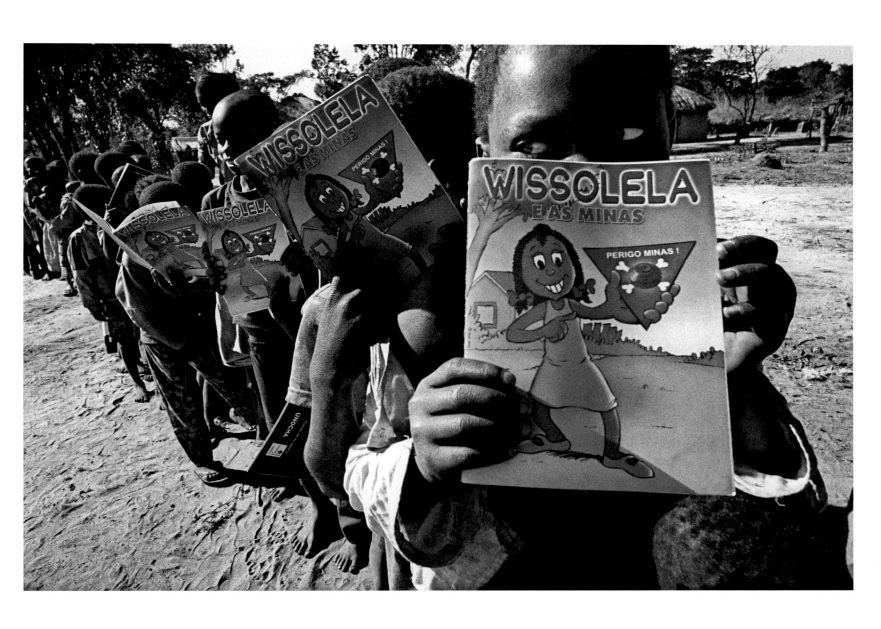

Children with mine risk education comic books
distributed by MAG's community liaison staff.
Luau, 2004

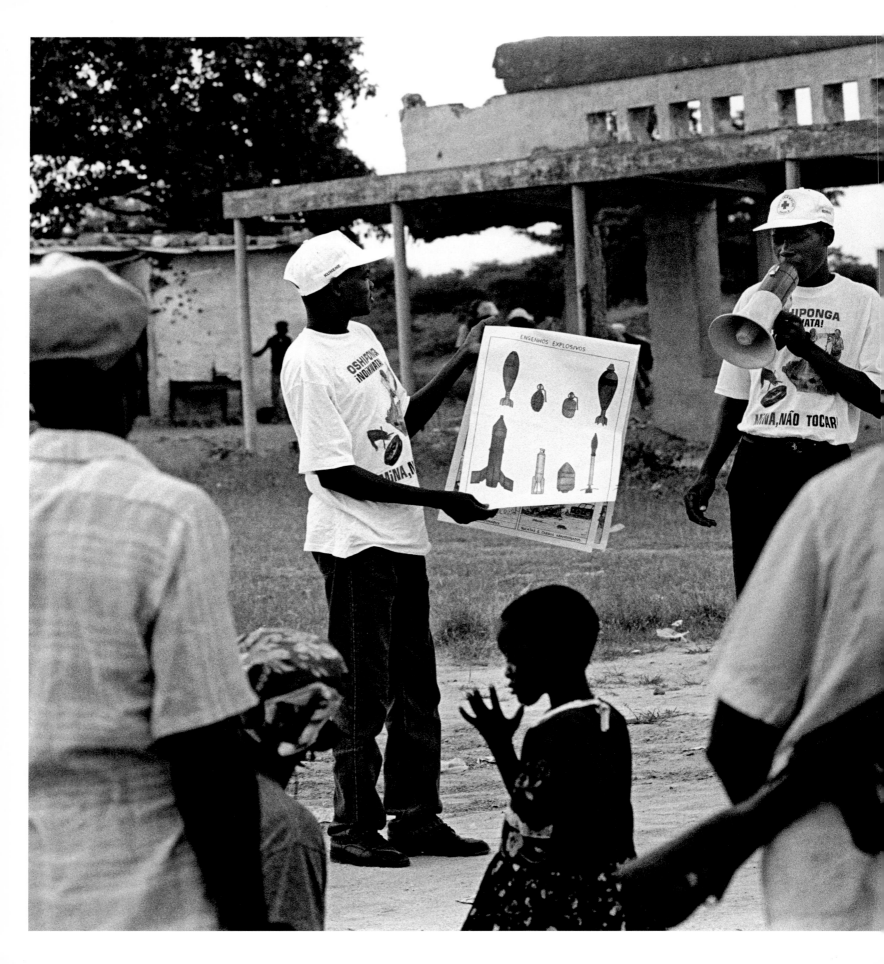

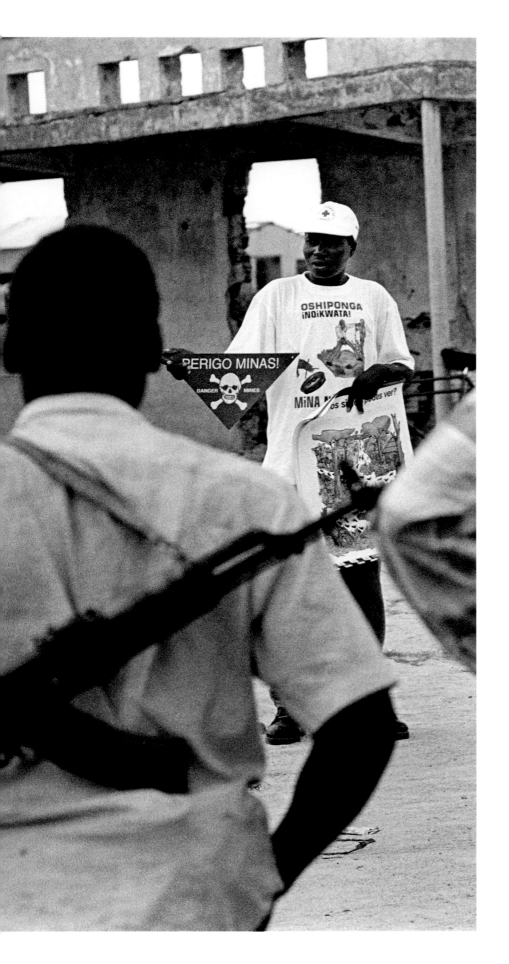

Mine risk education in Cunene
province. MAG teams visit thousands
of affected communities every year
to help people minimise the risks
of living in an environment
contaminated with landmines
and unexploded ordnance.
Ondjiva, 2000

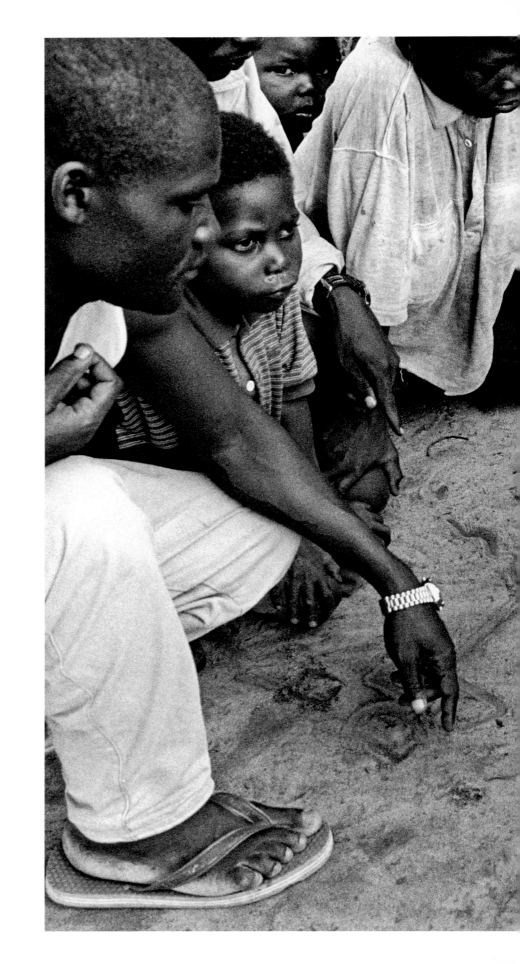

Community liaison staff work with
local people to establish the scale,
type and whereabouts of their mine
and UXO problem. Here villagers are
drawing a map of Lumege town and
indicating places where they know of
mines and UXO. The stones represent
mines and the mangoes represent UXO.
Lumege, 1997

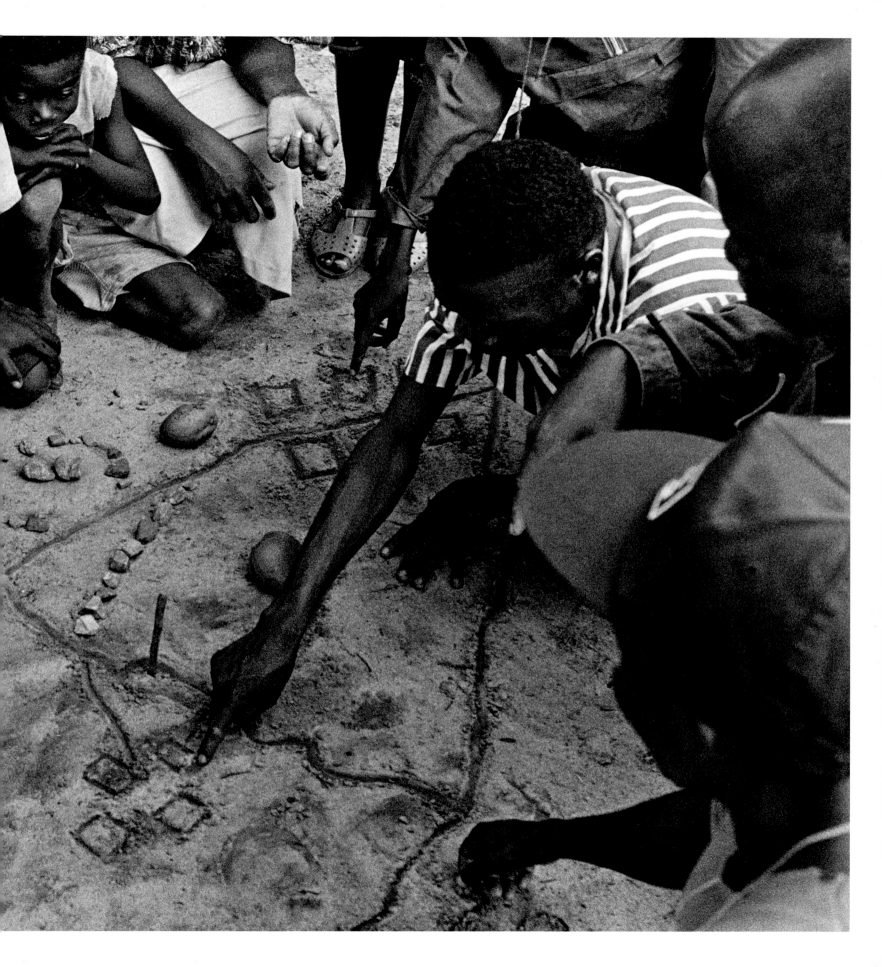

A man began clearing an area near the centre of town to build a house for his family. He dug up two mines and was lucky not to have set one off. A MAG team immediately cleared through to the mines and removed them. The area was still dangerous, and so it was marked with mine signs and staff discussed the situation with the community, telling them to stay away until a team could come back and clear the area.
Luau, 2004

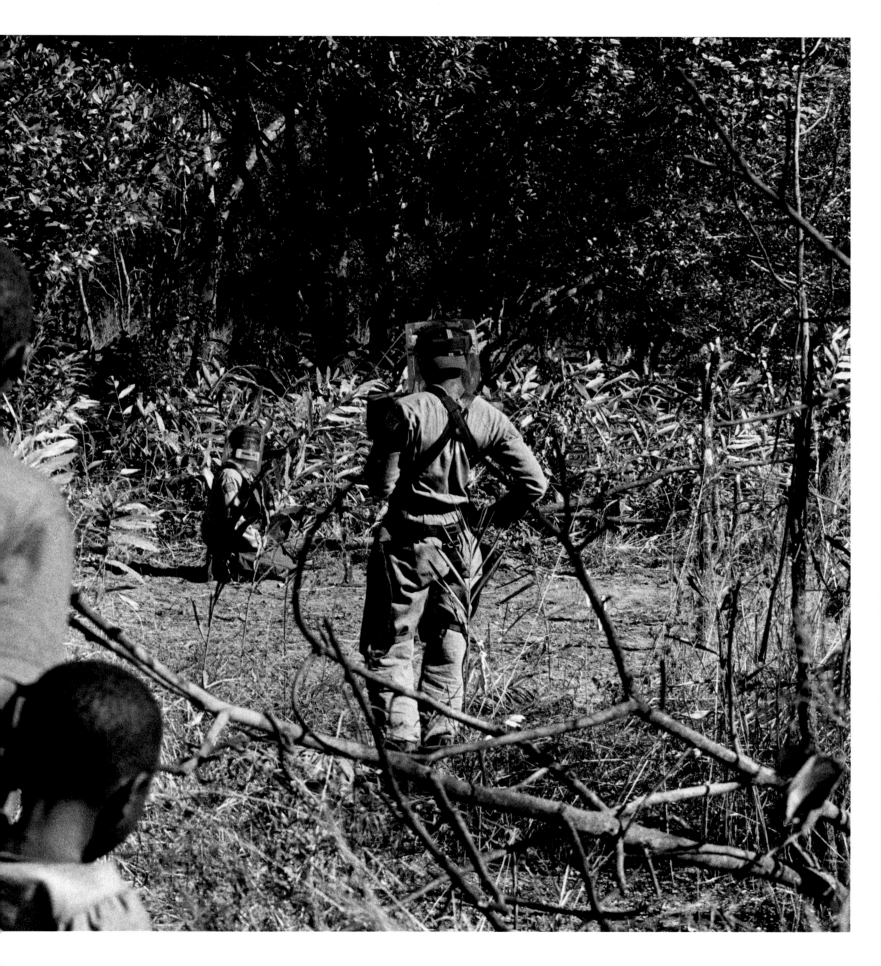

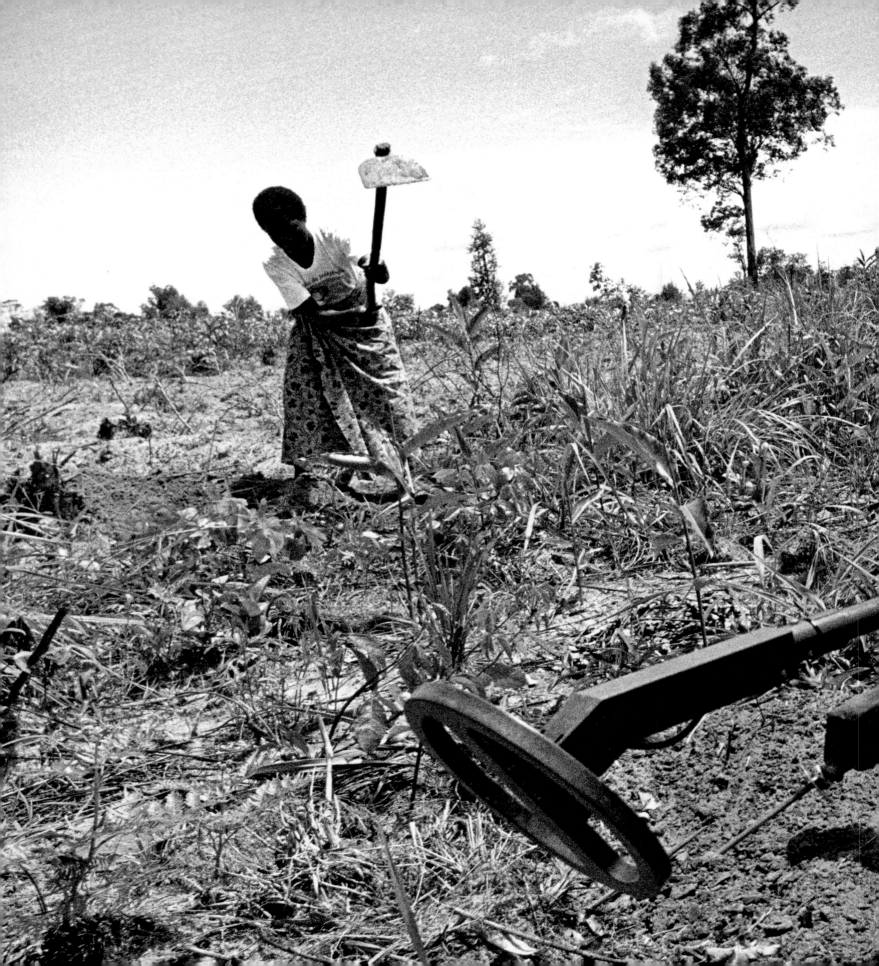

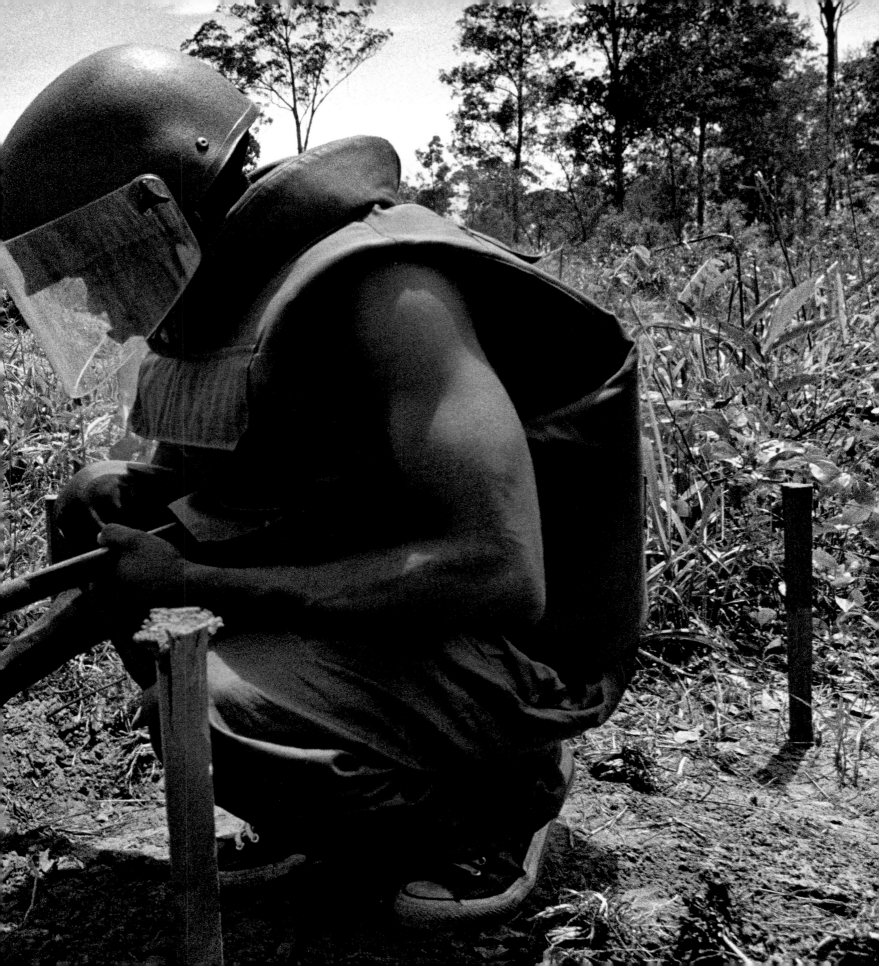

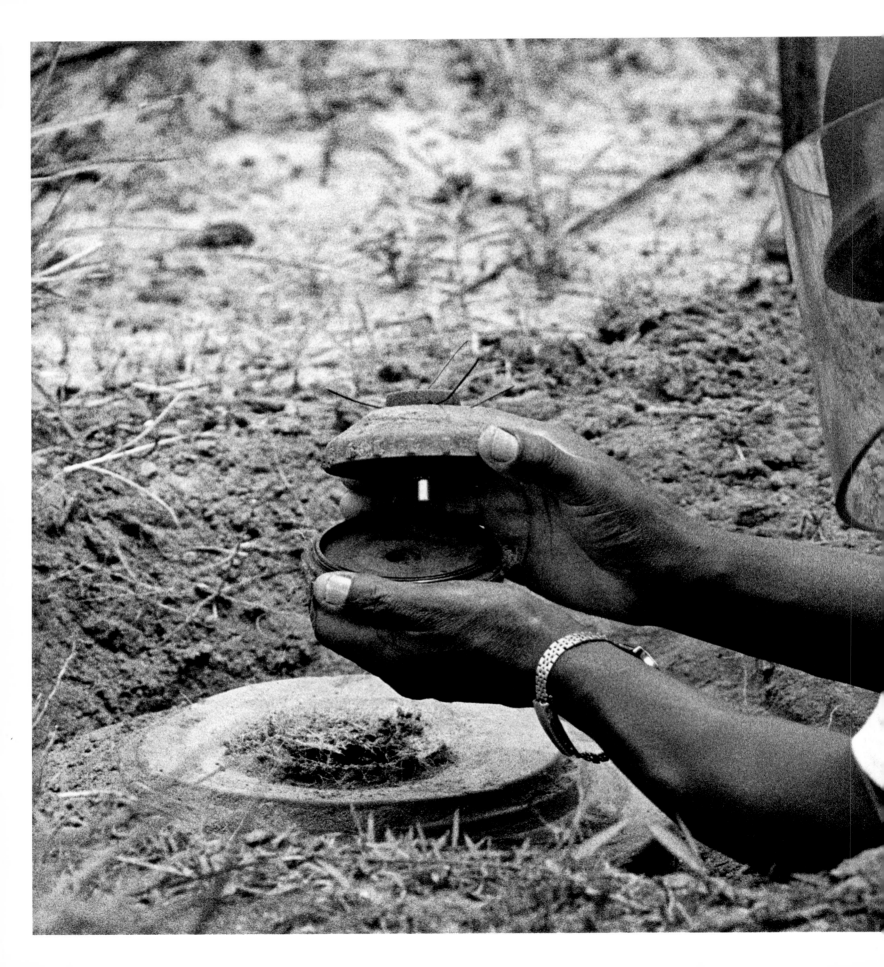

Previous pages:
The desperate need — as soon as it is
cleared, people cultivate the land.
Luena, 1995

Left: A deminer carefully opens an
MAI75 anti-personnel mine revealing
the detonator. This mine has been
placed on top of an anti-tank mine.
Using an anti-personnel mine to
trigger an anti-tank mine was
common practice in Angola.
Luena, 1995

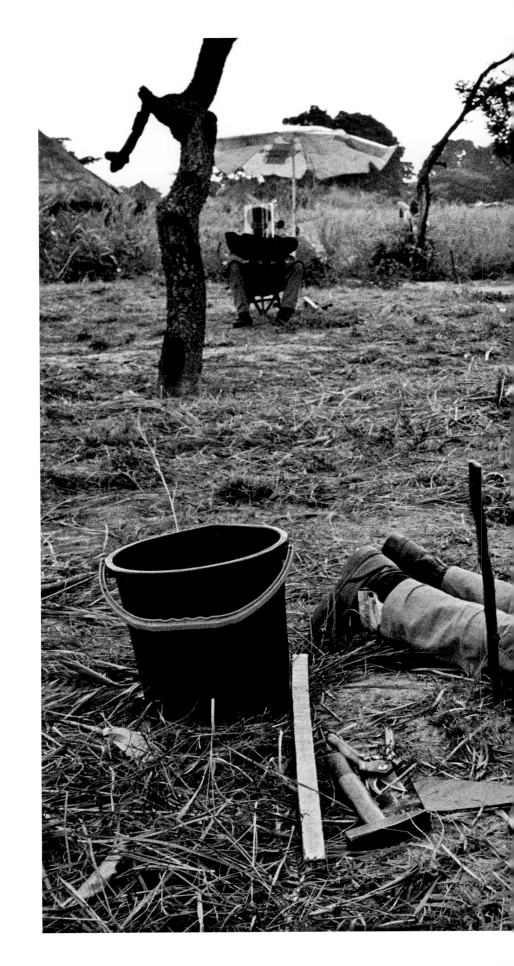

Muxito Sambo carefully uncovers
a PPM2 anti-personnel mine in
Jika bairro. Hundreds have been
found here all around the houses.
The deminer under the umbrella
is watching him for safety reasons.
The two will switch every
30 minutes.
Luau, 2004

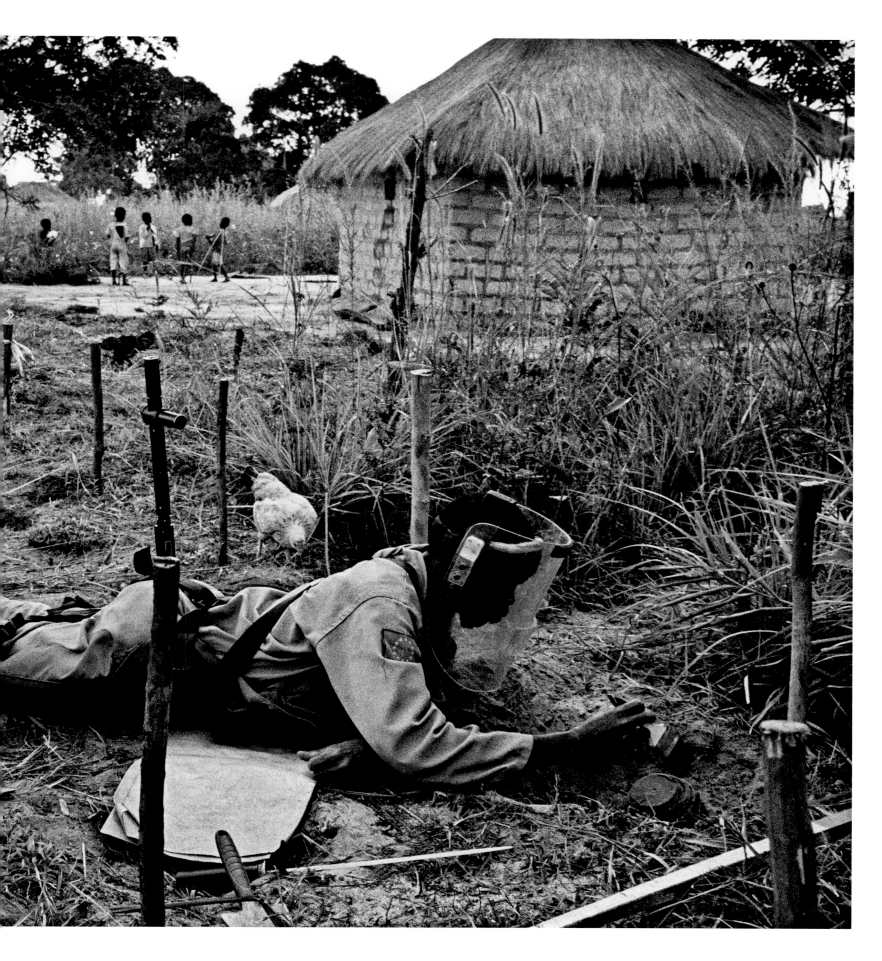

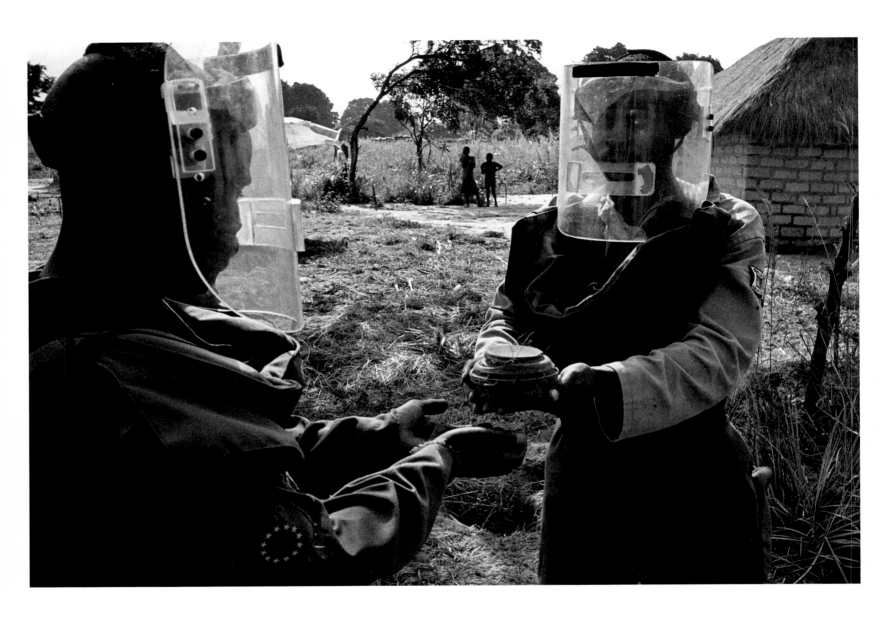

The mine is handed to Simao, team leader of one of the teams. "I have
worked with MAG since 1996 and the thrill of seeing people use the land
we have cleared is the same now as it was then."
Luau, 2004

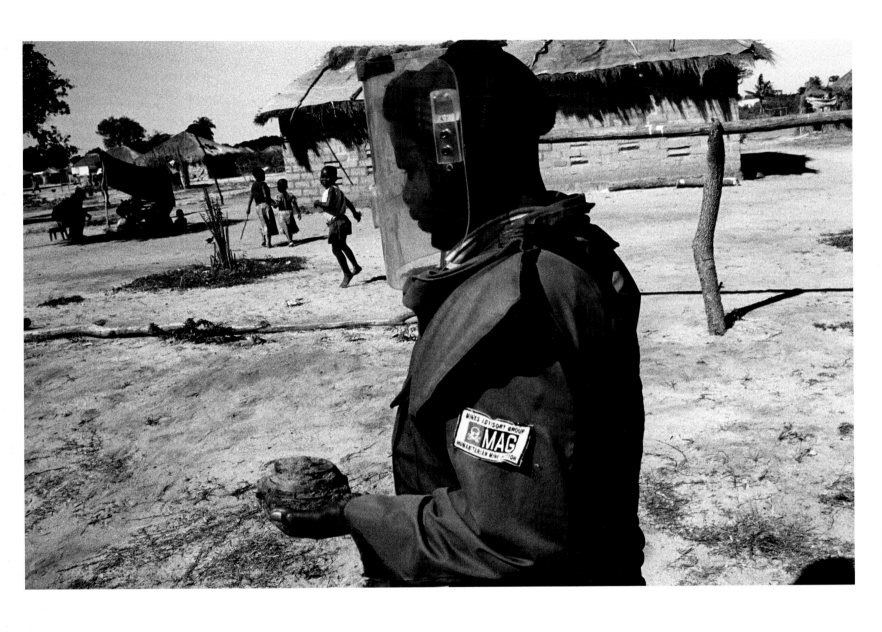

The mine is taken away to be safely destroyed.
Luau, 2004

Following pages:
An anti-personnel mine is safely destroyed in a controlled demolition.

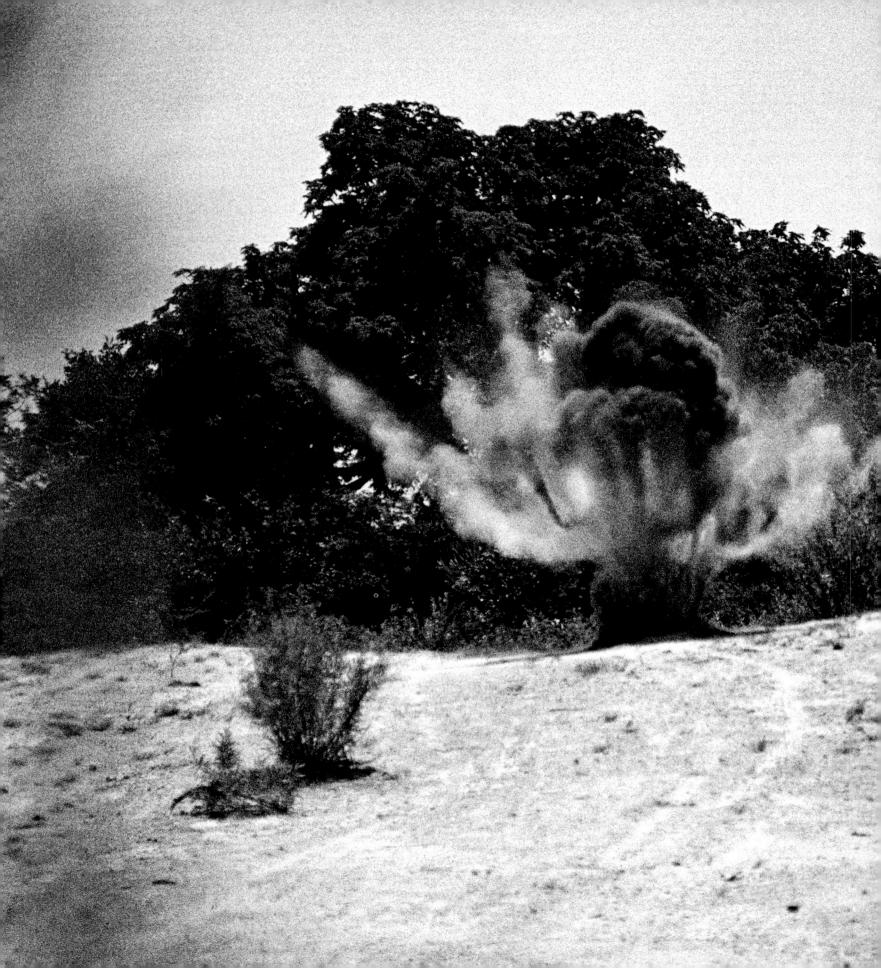

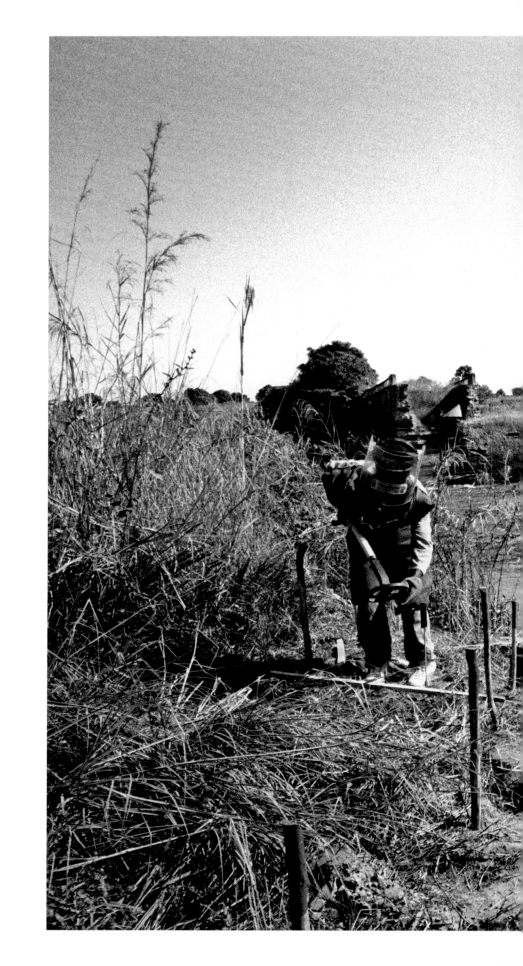

Deminers clear around the remnants of a vital bridge crossing the Zambezi. The work of MAG plays a vital role as part of the wider development of affected areas. When the clearance is completed the Government will rebuild the bridge opening up a large area. Cazombo, 2004

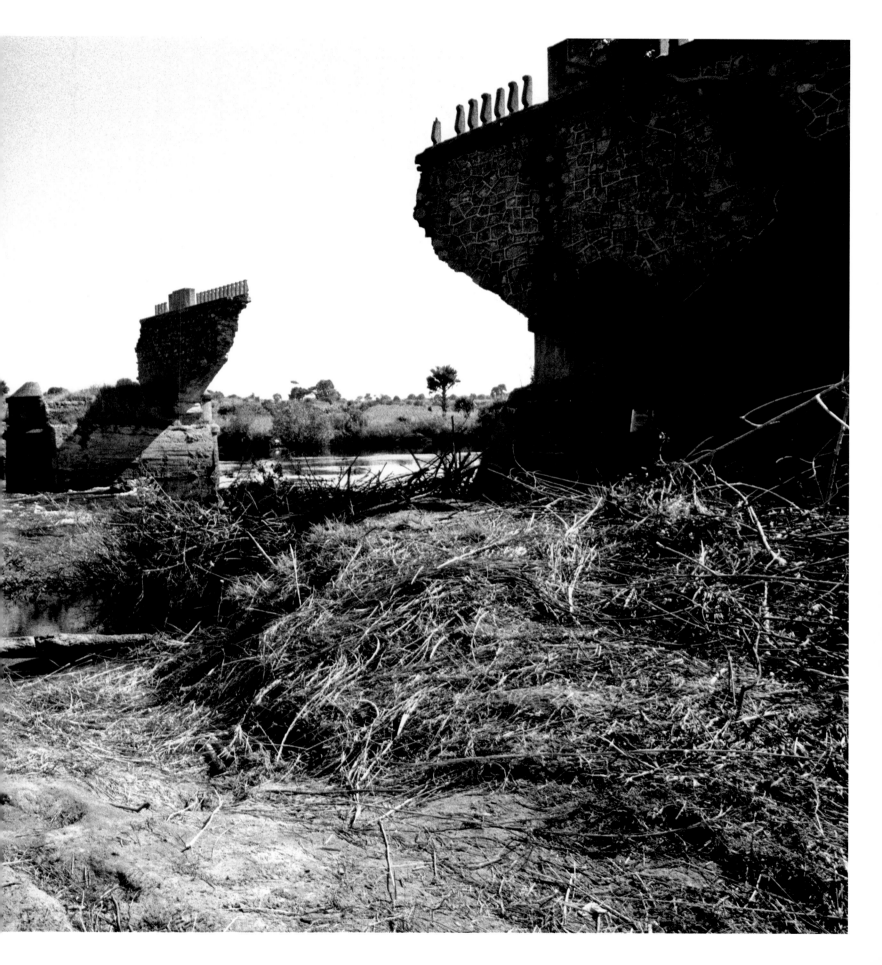

The tail unit of an RBK 250-275
cluster bomb being uncovered.
Luau, April 2004

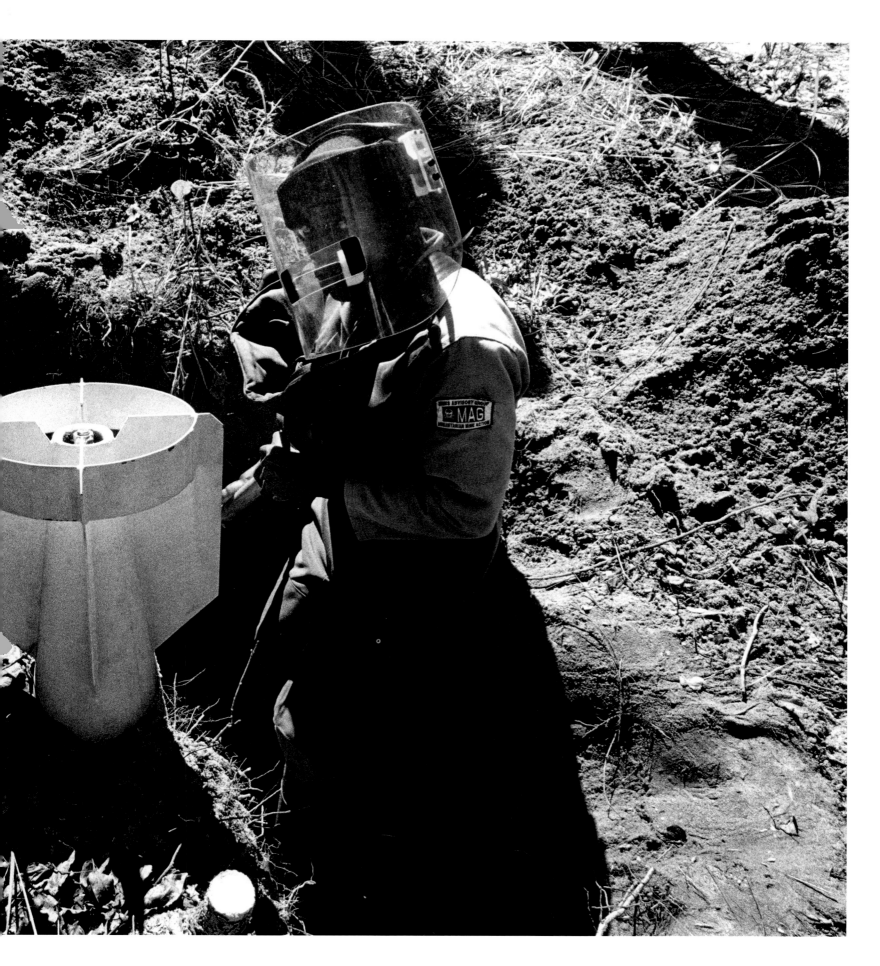

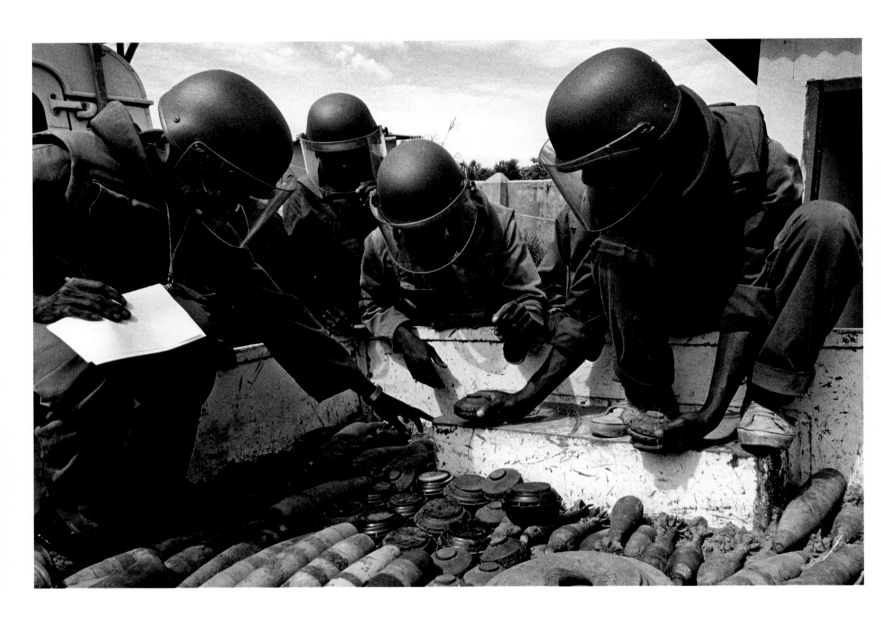

The week's harvest: Deminers record mines and unexploded
ordnance (UXO) found that week before safely transporting
them to a nearby demolition site.
Luena, 2001

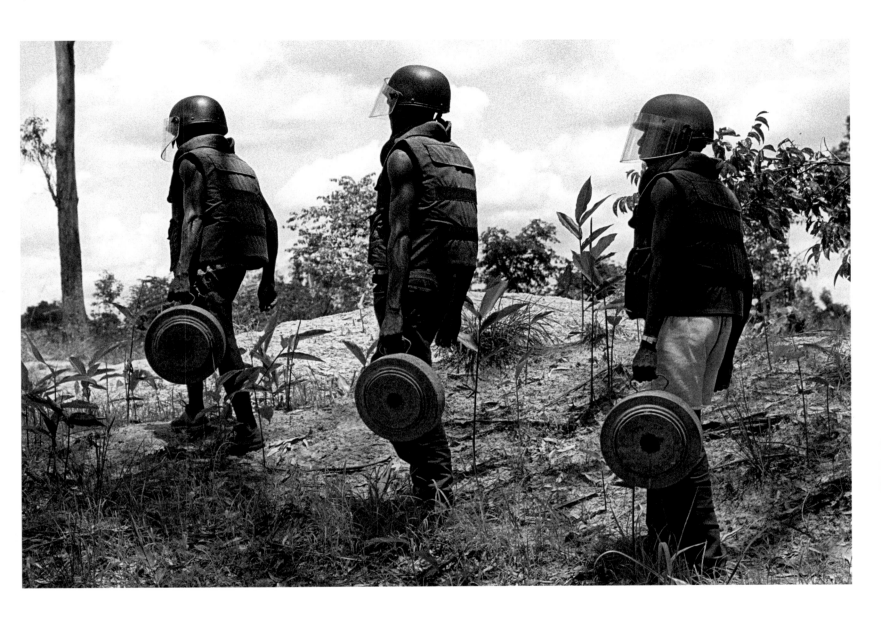

Deminers transport anti-tank mines to a demolition site. These mines
can be activated by ploughs and livestock as well as by vehicles.
Luena, 1995

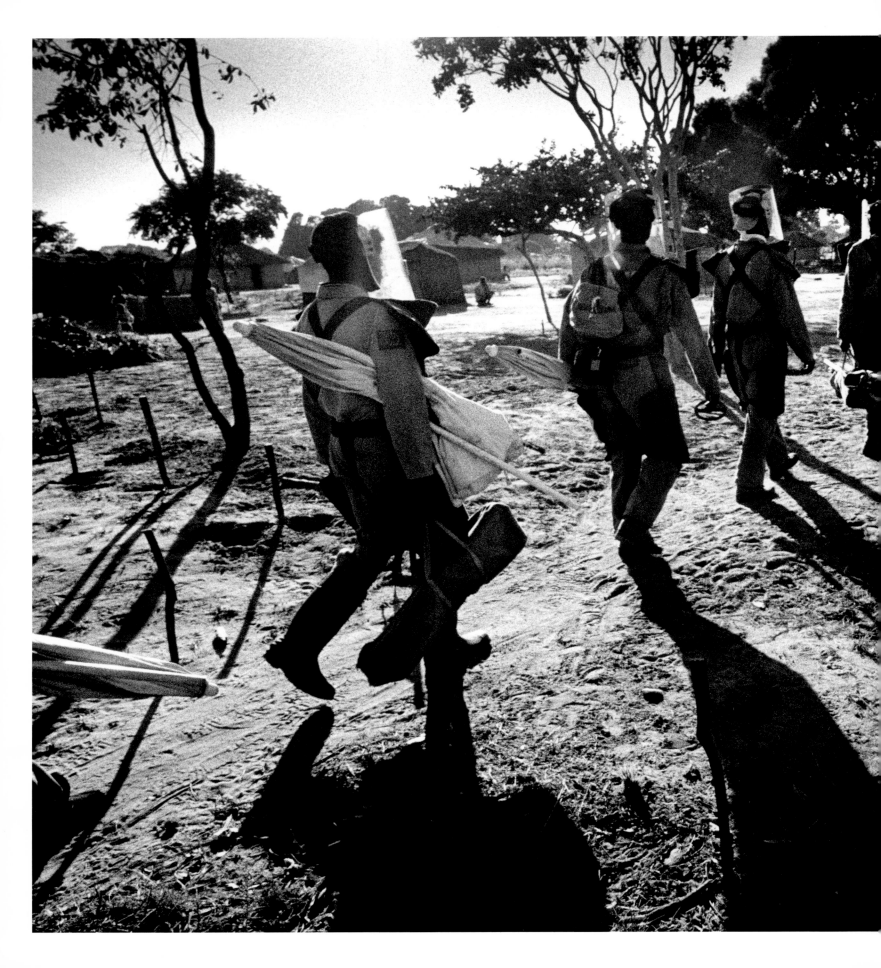

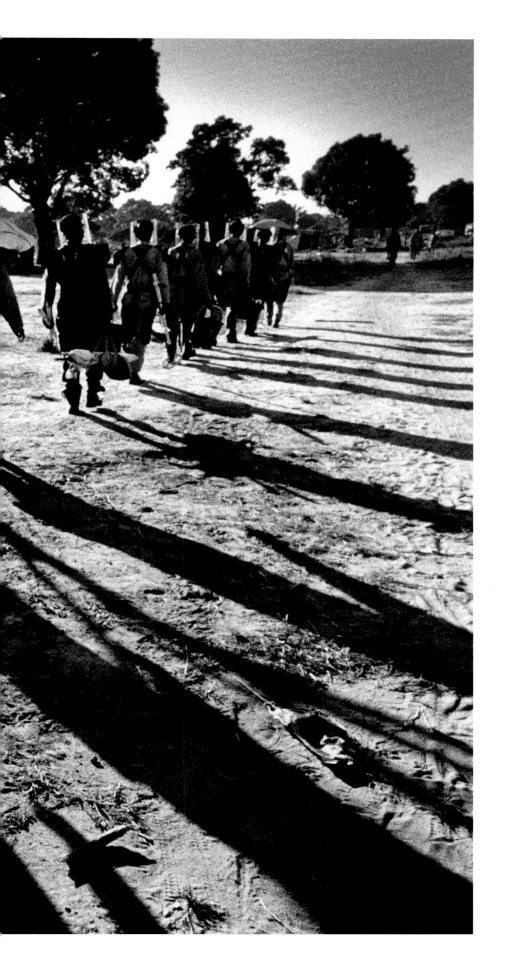

The team heads back to camp
after a long day's work.
Luau, May 2004

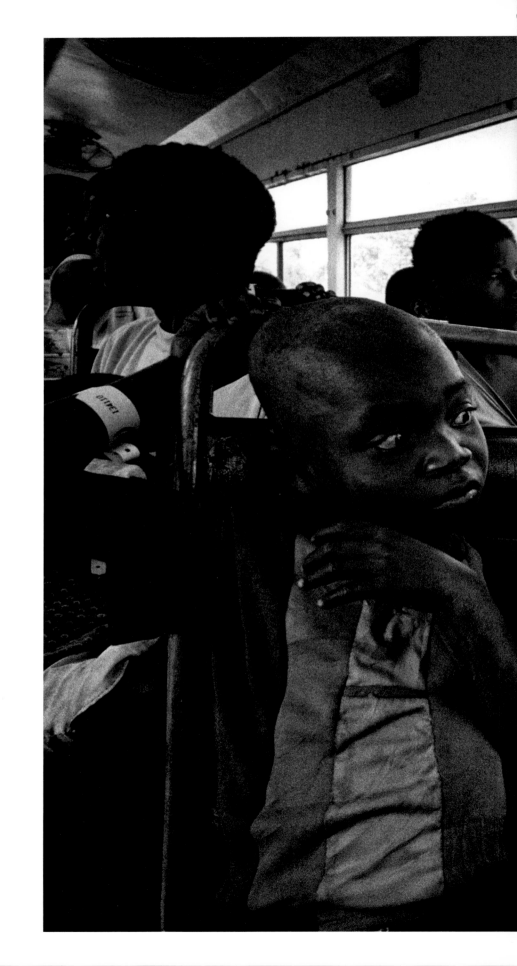

Refugees return home from the
Democratic Republic of Congo.
Nearly one thousand people are
arriving in Luau each week. For
the young ones, this is their first
glimpse of Angola.
Near Luau, 2004

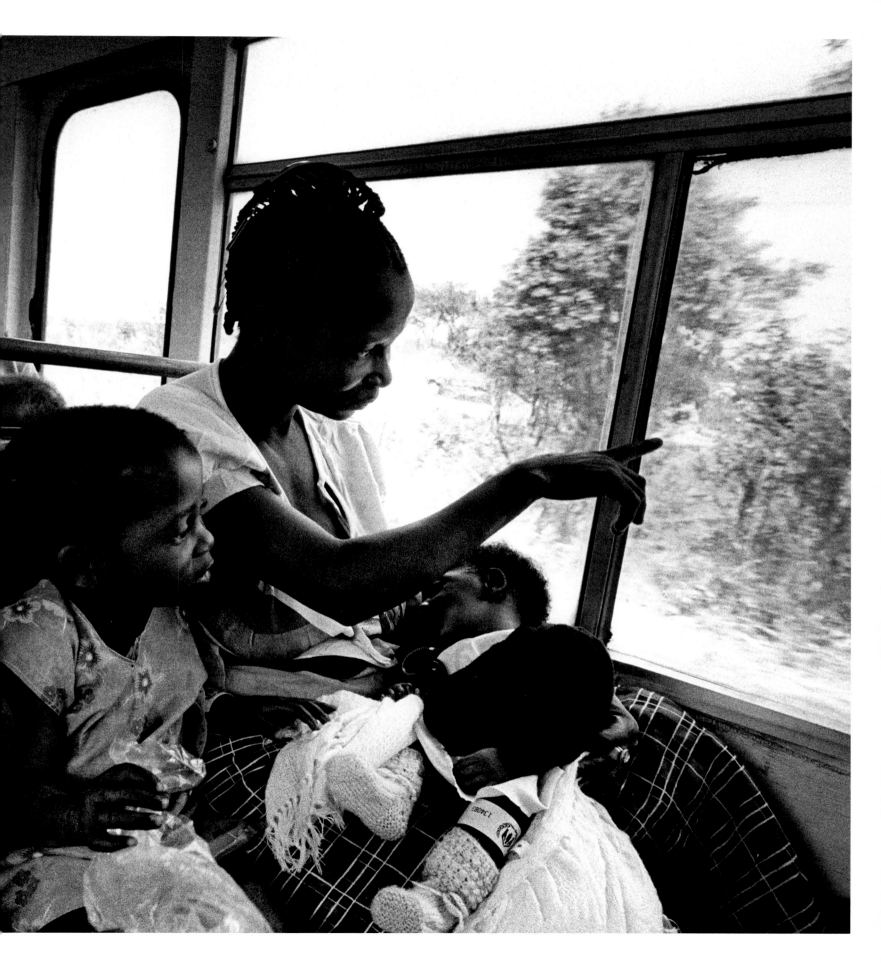

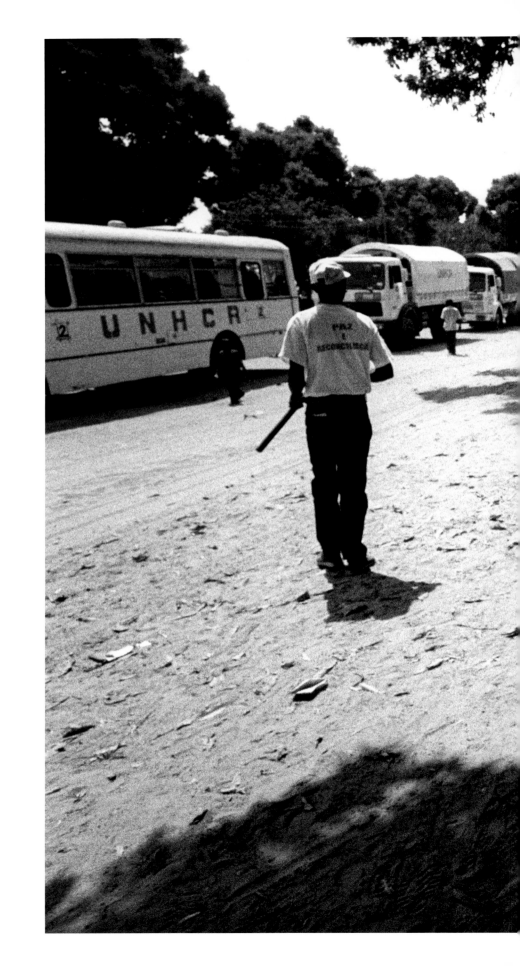

People are held back by barricades and truncheon-wielding guards wearing 'peace and reconciliation' t-shirts as the convoys arrive at the reception centre. Everybody is desperate to catch sight of friends and family.
Luau, 2004

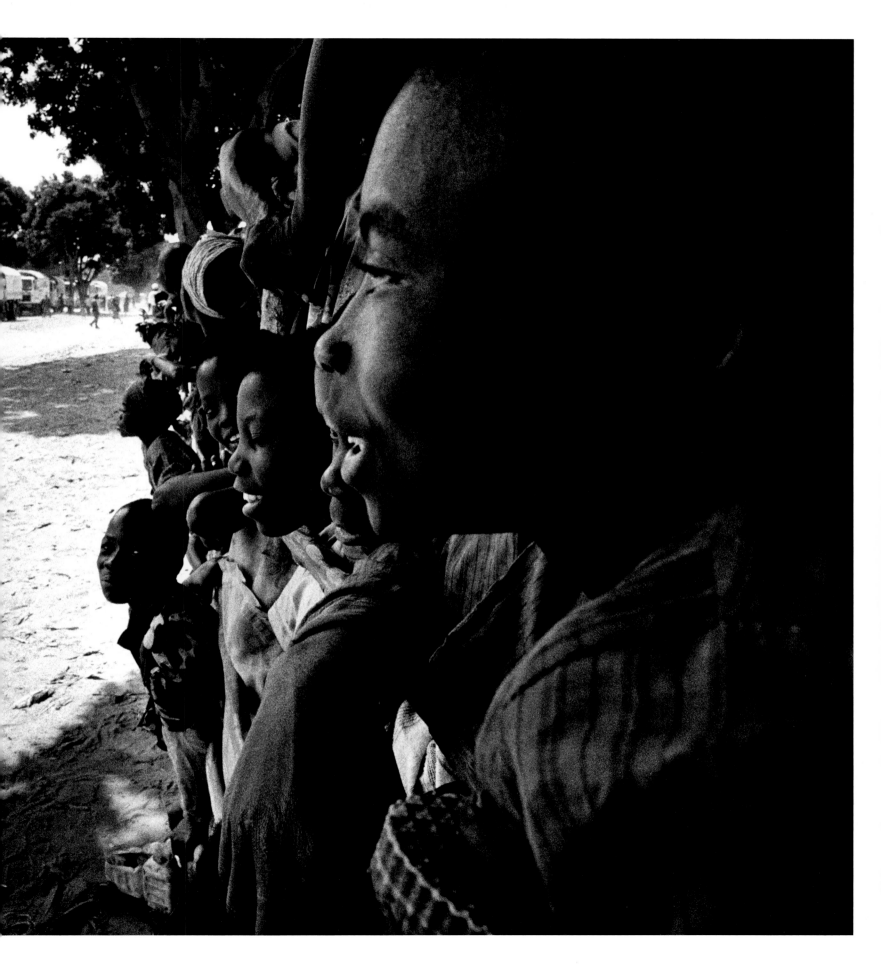

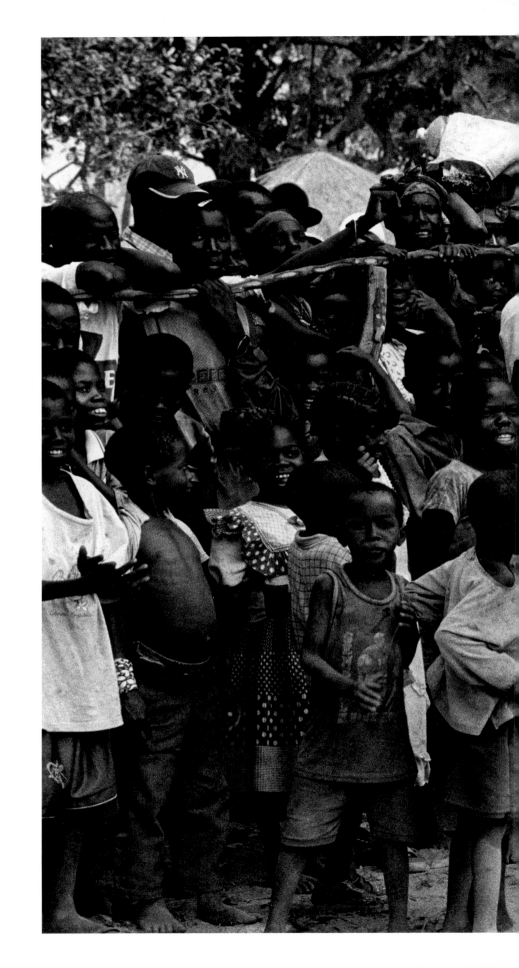

It is a euphoric occasion. People
wave and shout as they recognise
friends and relatives.
Luau, 2004

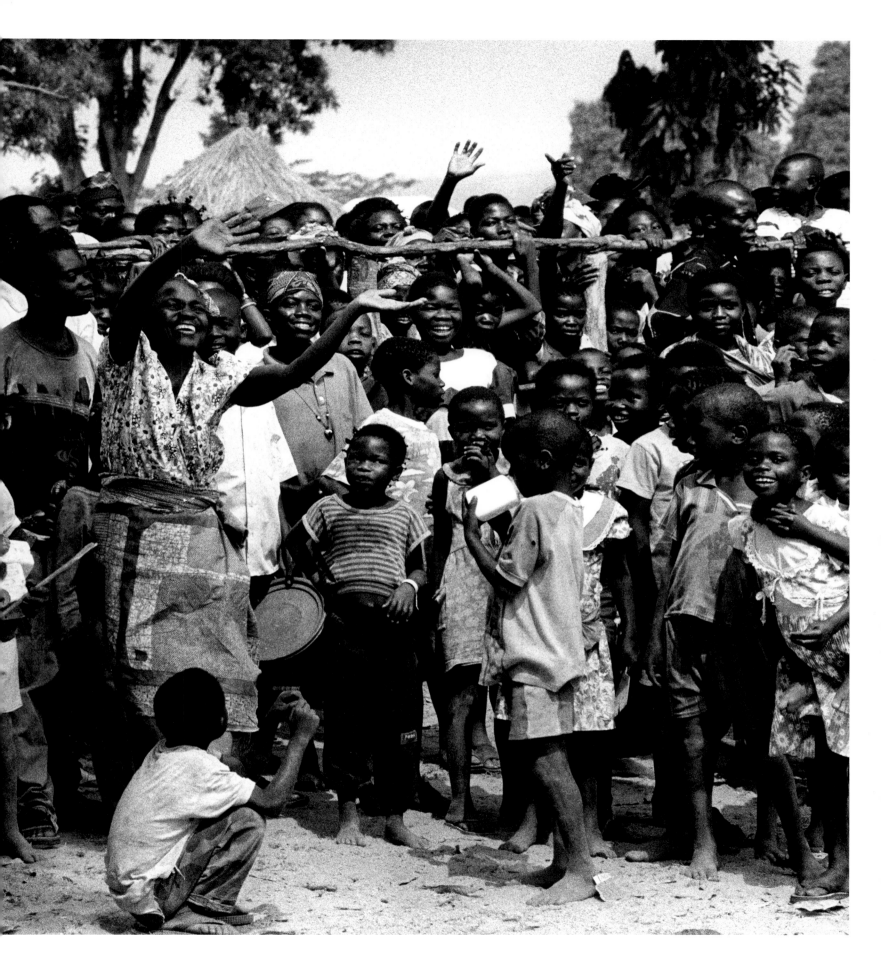

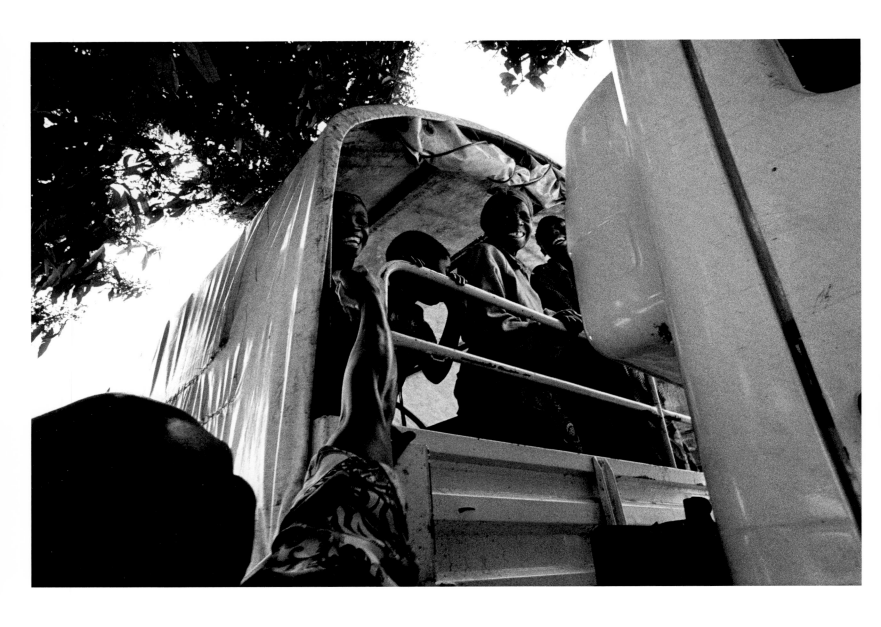

Some of the crowd manage to get through the barrier and meet
relatives they have not seen for years.
Luau, 2004

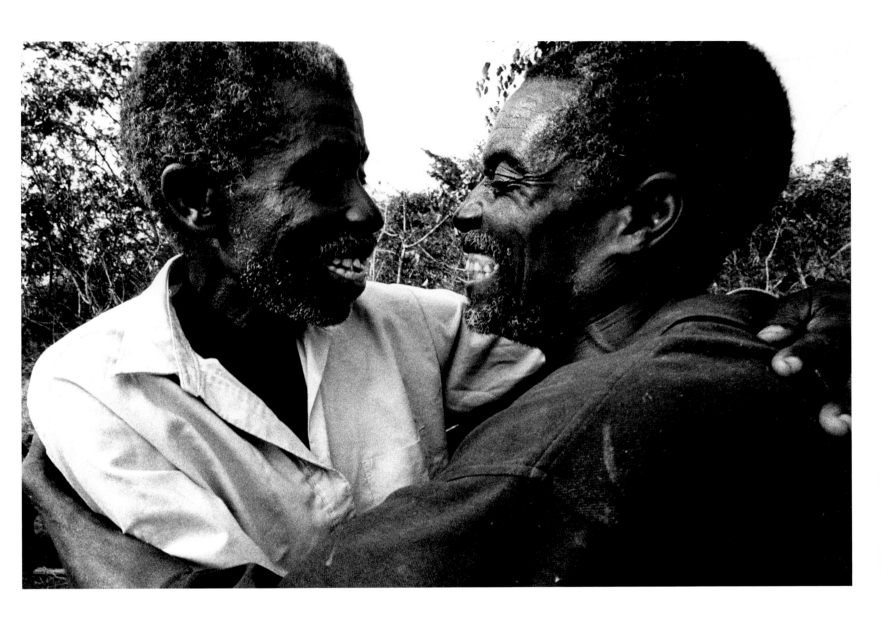

Brothers meet for the first time in fifteen years.
Luau, 2004

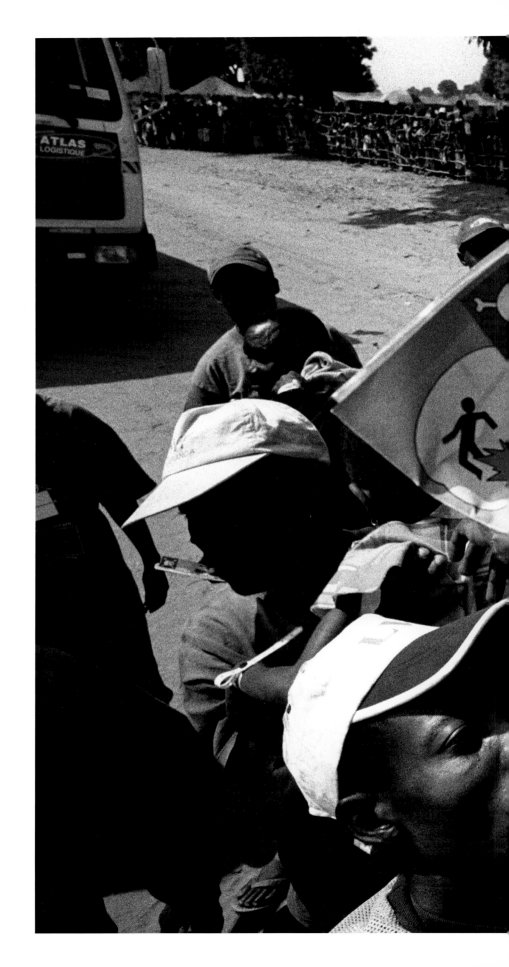

People are helped out of the
trucks and buses.
Luau, 2004

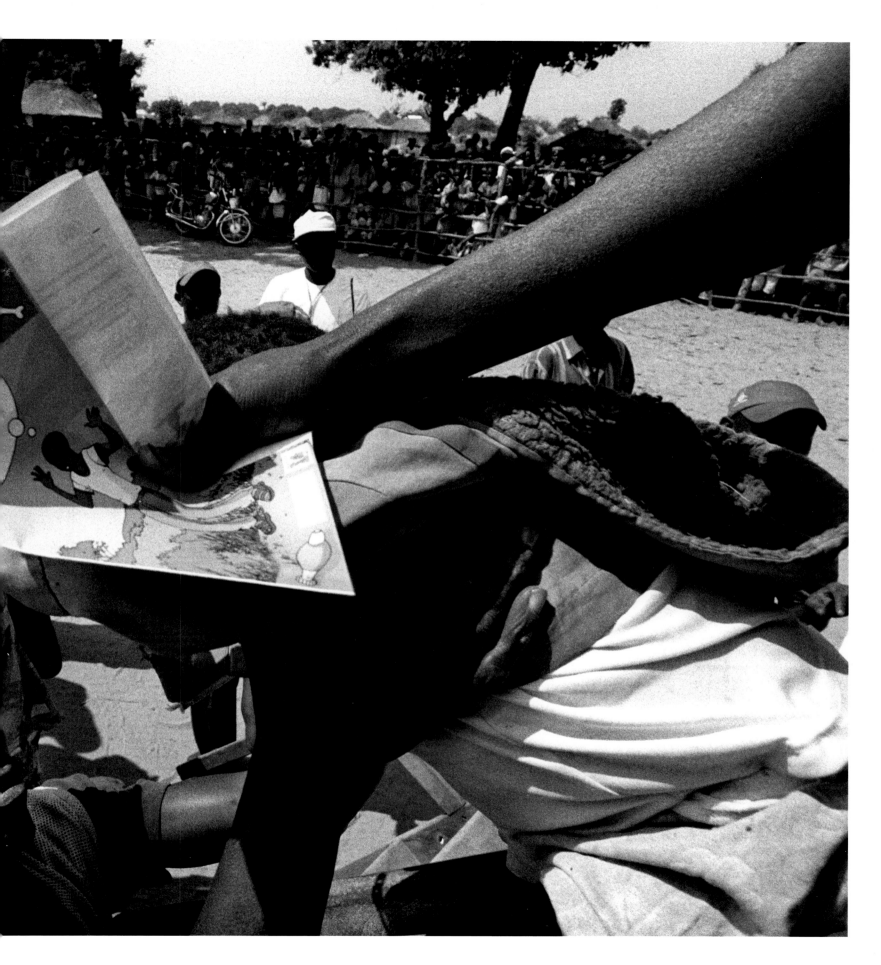

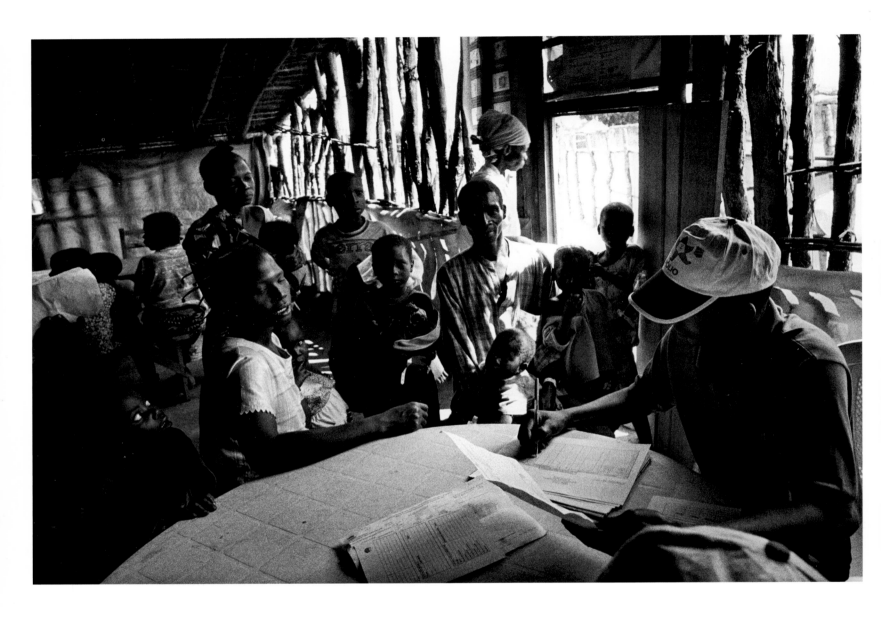

Returnees spend three days in the reception centre where they are
registered. If they haven't already organised a plot of land through relatives,
they are told where they can build their homes and rebuild their lives.
Everyone is given mine risk education, AIDS awareness, a medical check,
food, cooking utensils and plastic sheeting.
Luau, 2004

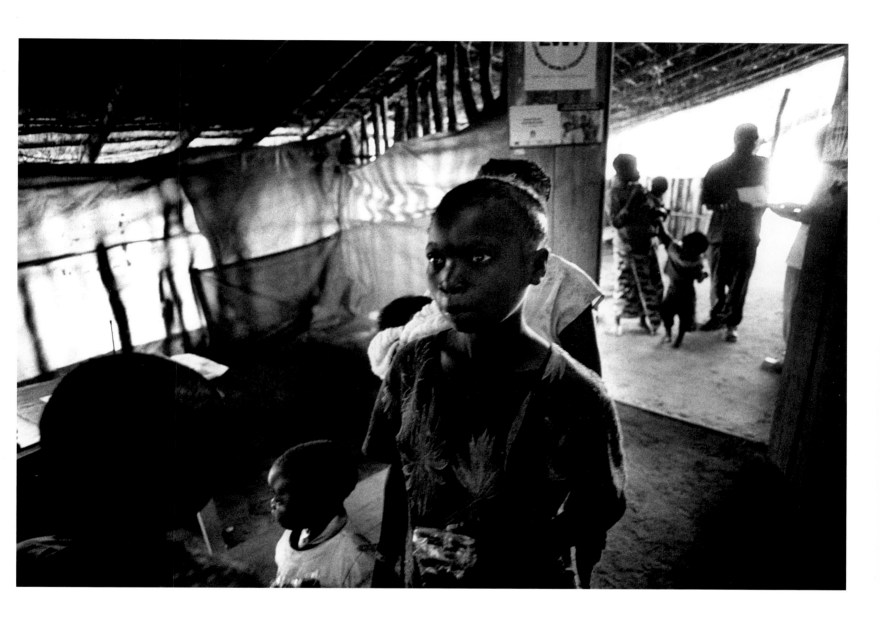

Following pages

Top Left: Families wait with all their belongings for trucks to take them to their final destination.

Bottom left: Trucks are loaded

Right: A heavy load.

All Luau, 2004

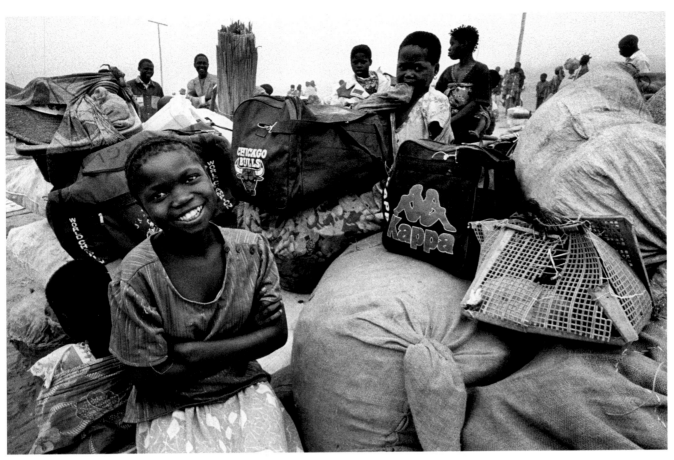

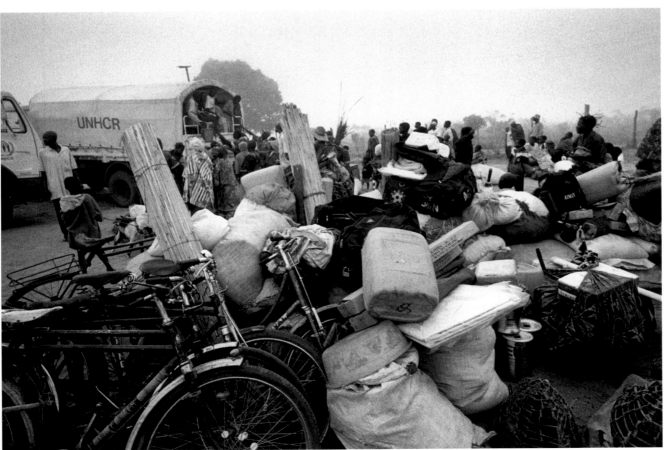

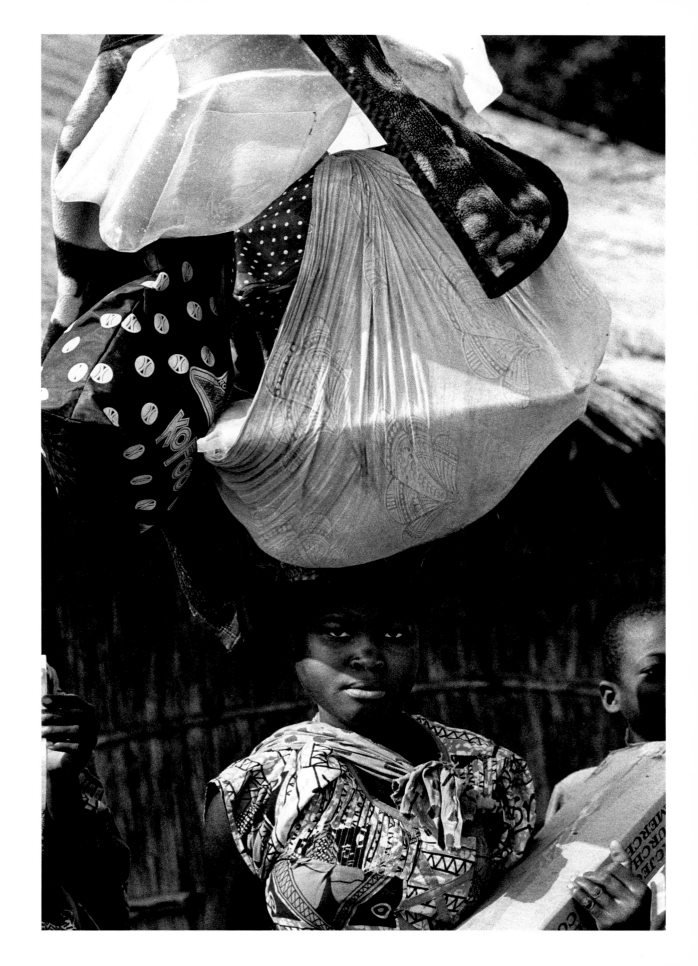

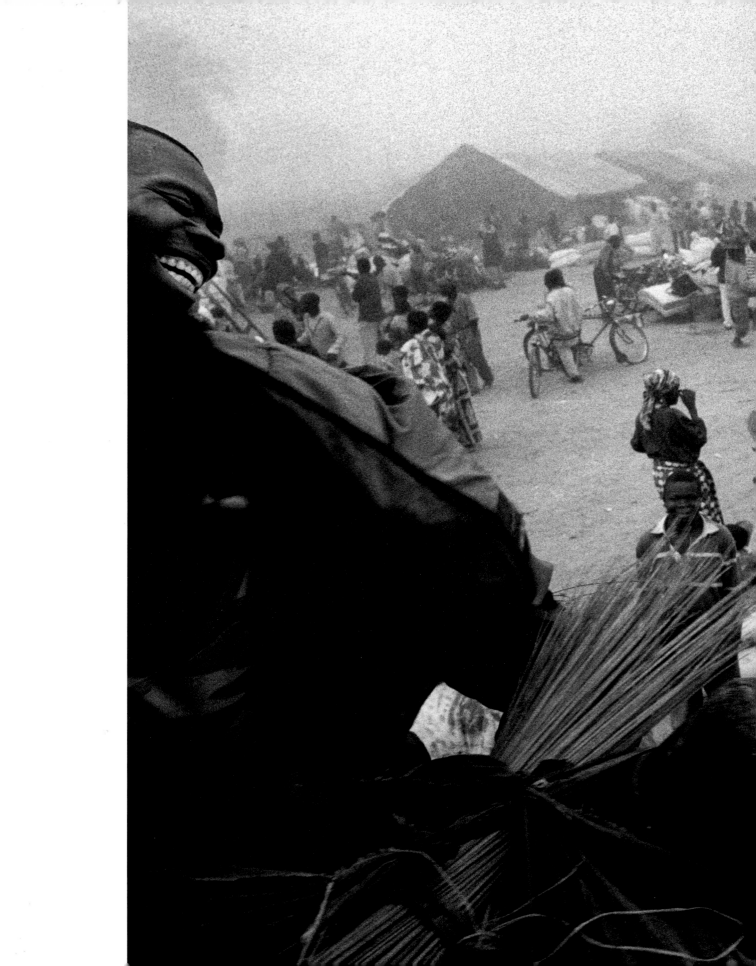

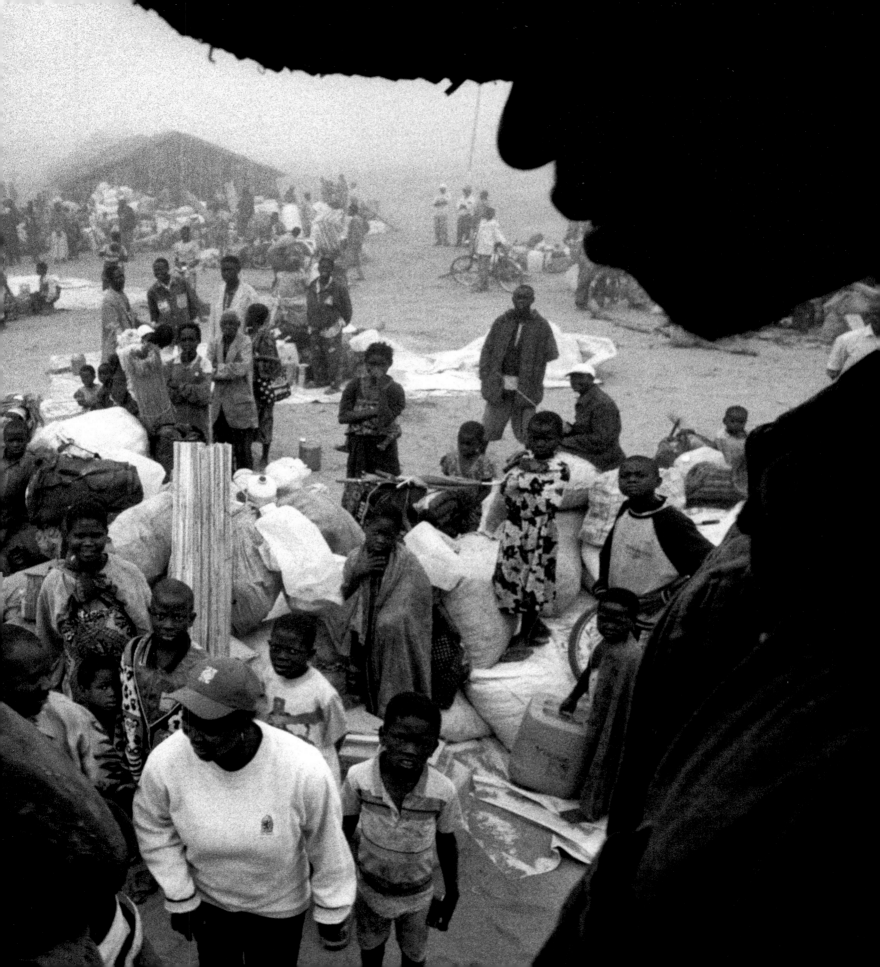

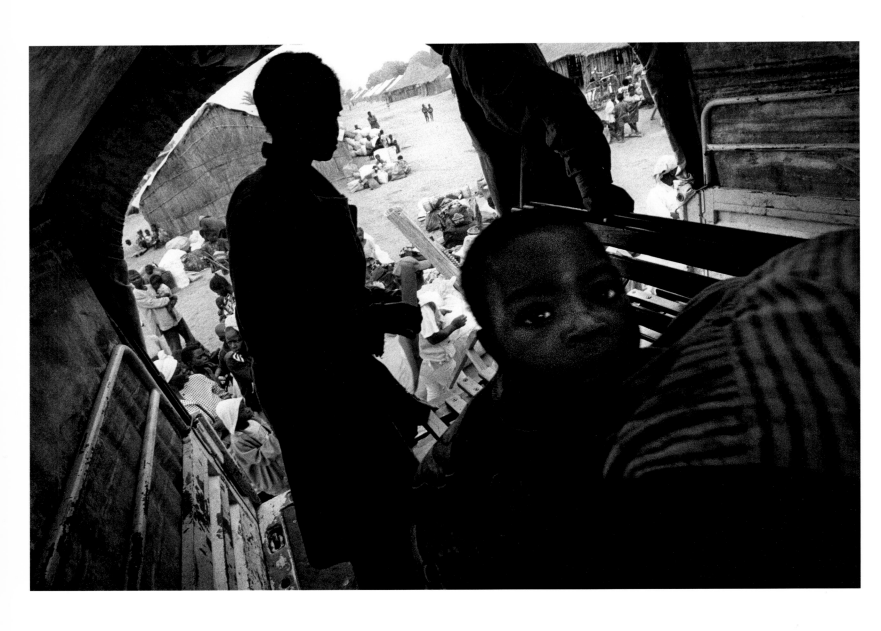

People are helped up into trucks. The final stage of a long journey home.
Luau, 2004

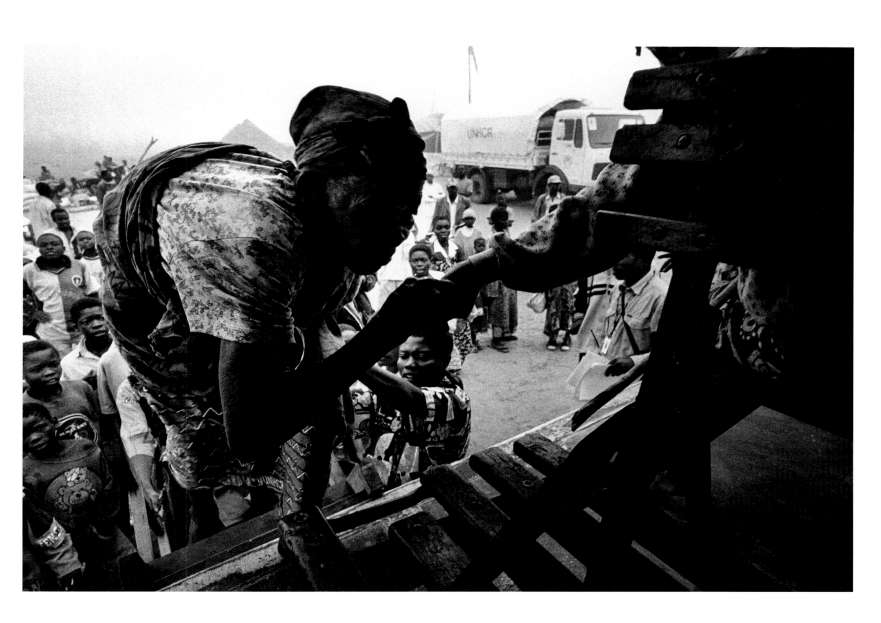

Tragically Luau is surrounded by
minefields. There are even minefields
in the town itself. There is not enough
safe land available. Newcomers have
no choice but to risk themselves and
their families.
Luau, 2004

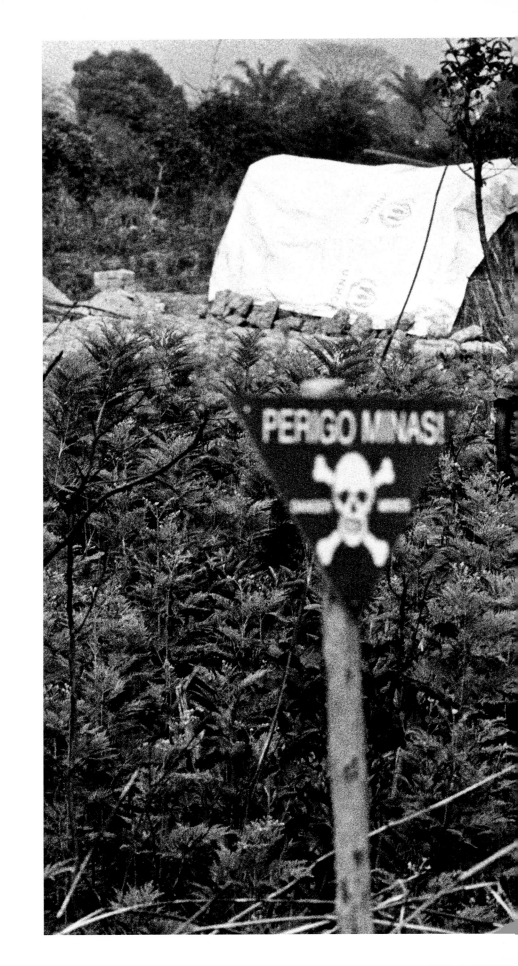

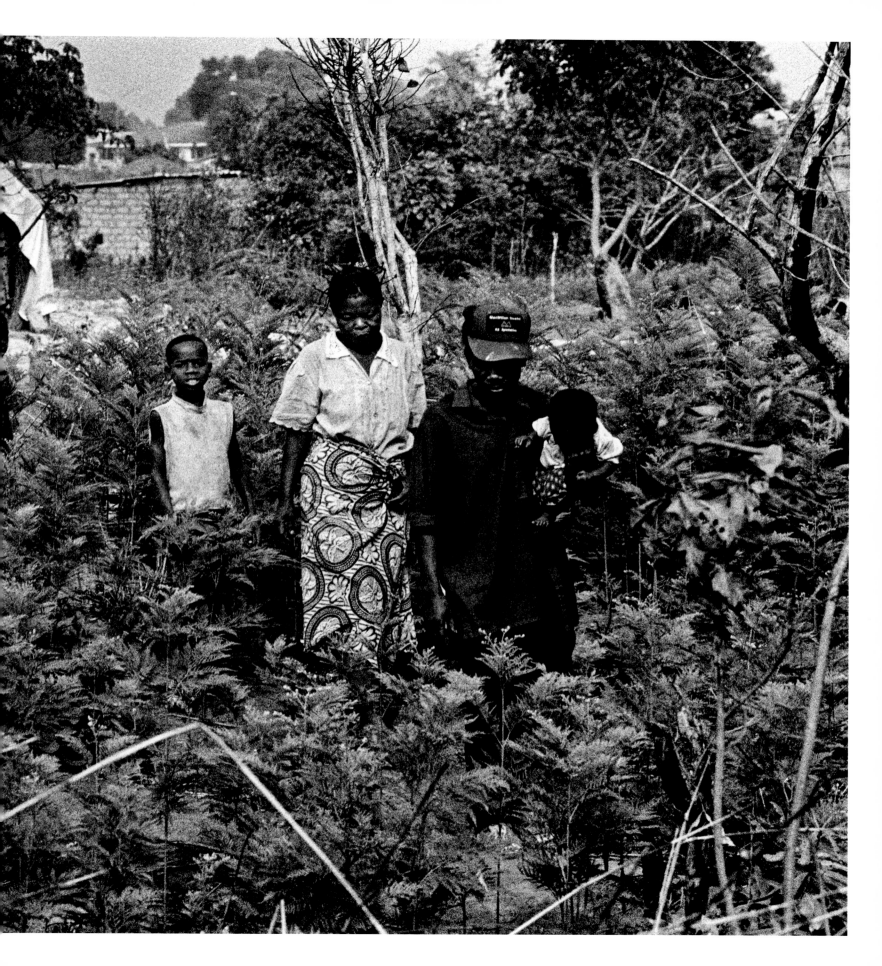

A young family has just arrived.
They are clearing an area to build a
house in a known minefield. Three
weeks before the picture was taken
someone had been blown-up and
killed by a landmine five metres
away from where the man is
walking.
Luau, 2004

Following pages:

This family has just arrived this
morning. "We lived near here many
years ago but now someone else
has set up home. I found this mine
warning sign here but we have
nowhere else to go. I hope there are
no mines. I am very afraid for my
children."
Luau, 2004

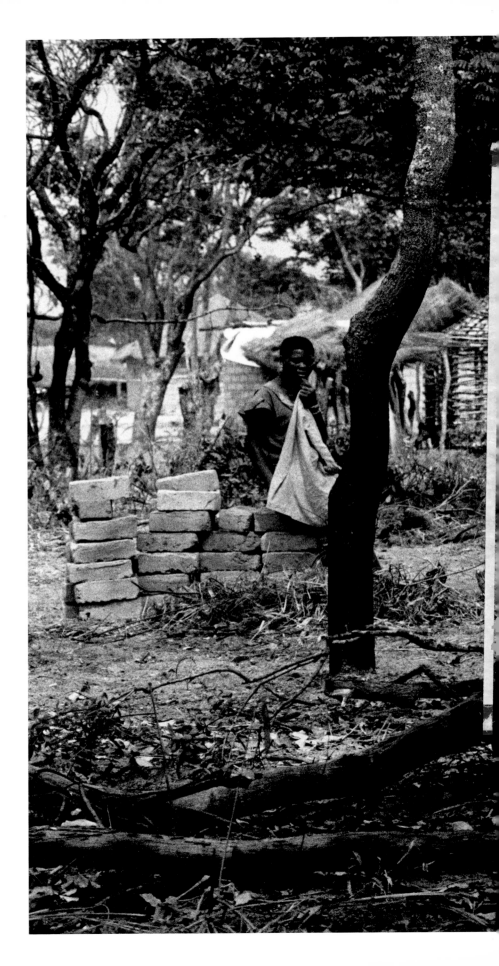

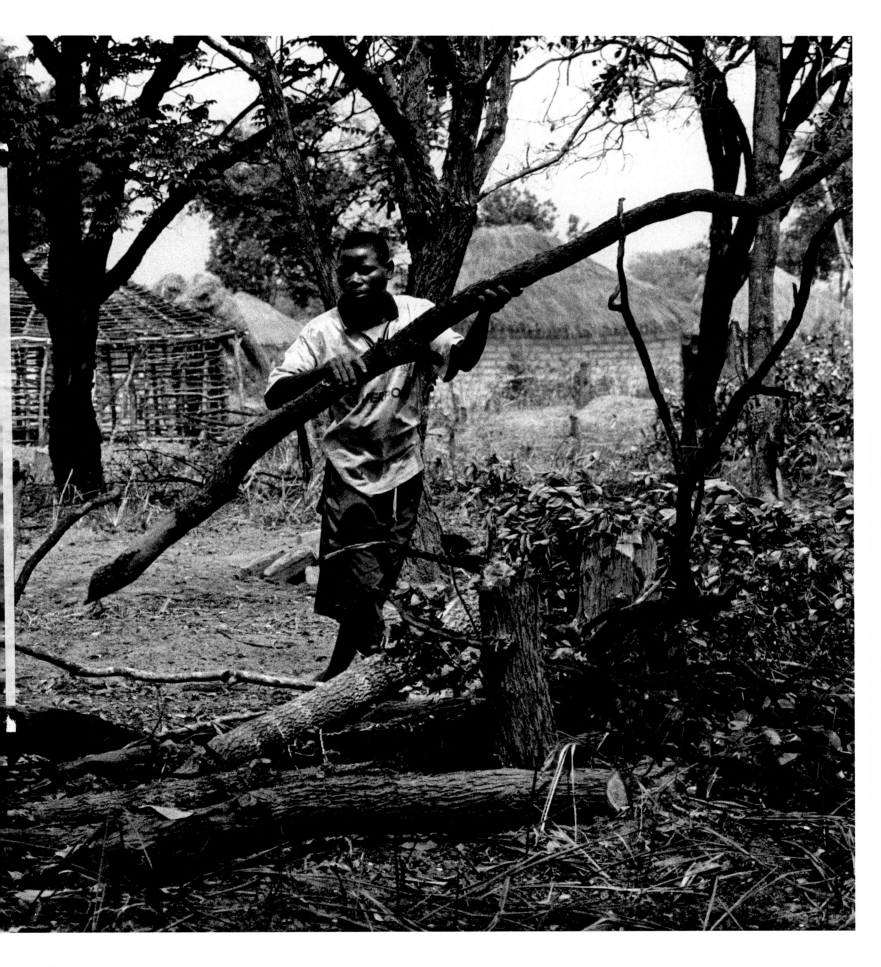

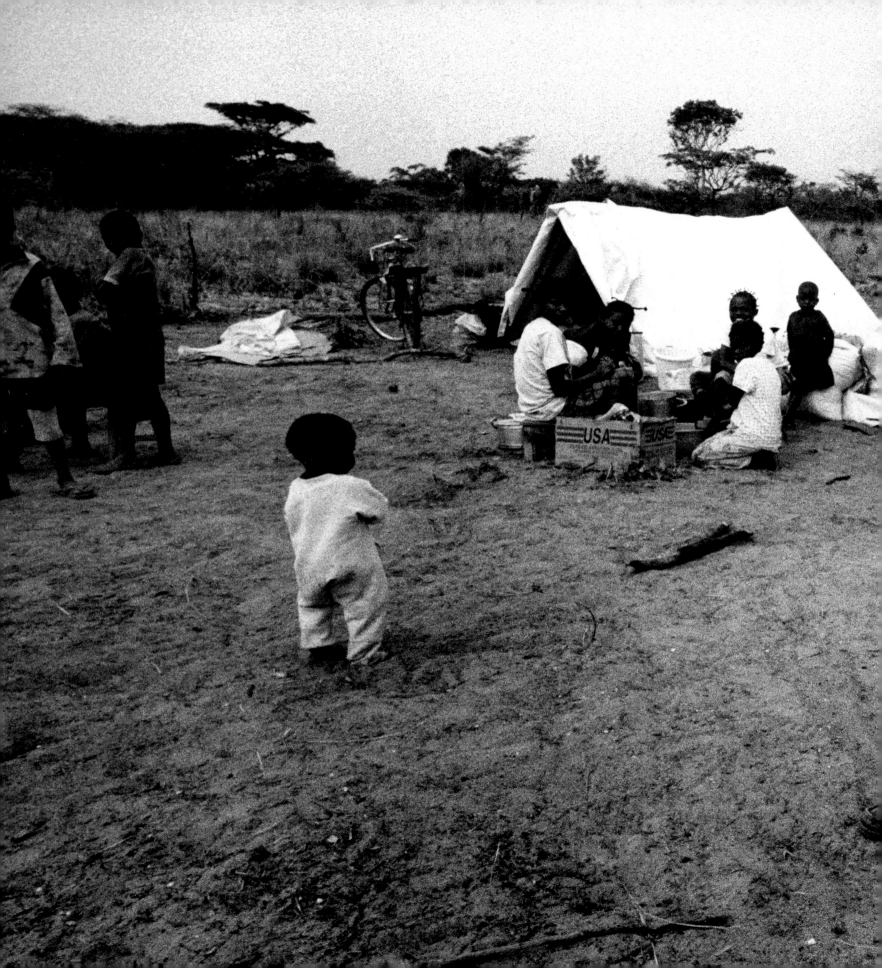

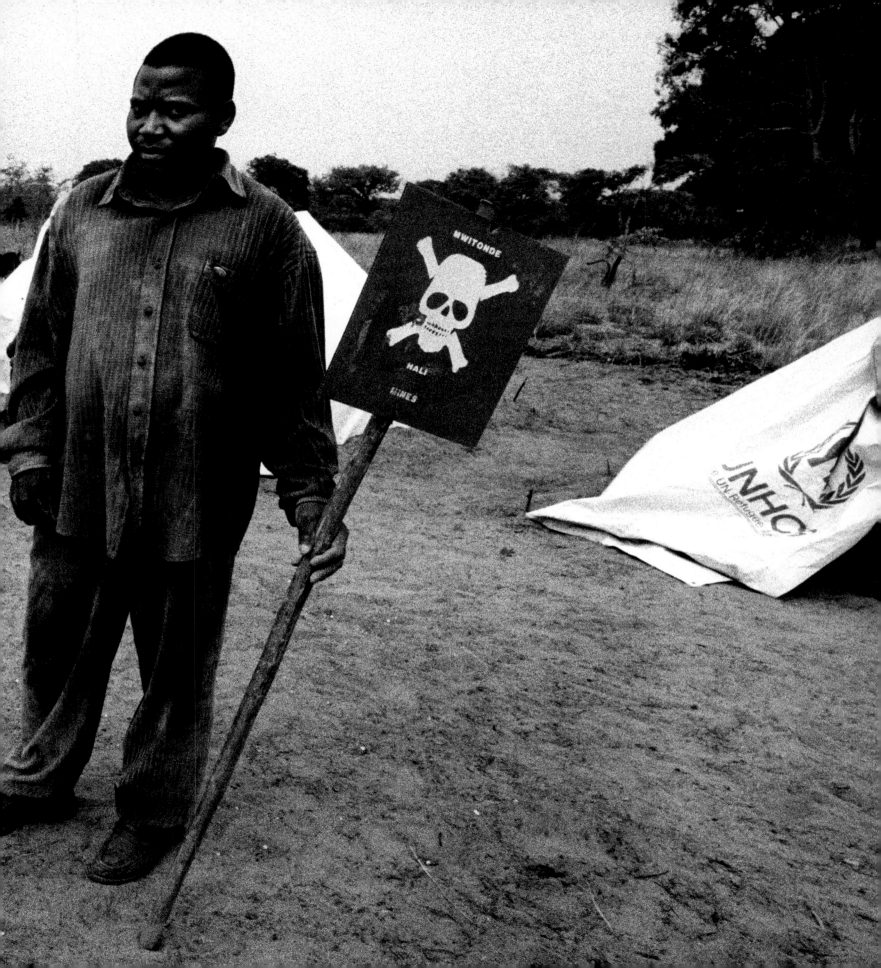

Sean Sutton: Biography

In 1988 Sean Sutton headed for South East Asia with some savings, a couple of cameras and a bag of film. He spent three months along the Thai/Burma border photographing the Karen, one of the Burmese minorities fighting the government, and documenting the life of the Burmese refugees in Thailand and the frequent battles along the border.

He then spent six months in England, had two successful exhibitions, and showed his work to newspaper and magazine editors. He returned to the Thai/Burma border armed with a sponsorship from Agfa and support from UK newspapers. Publication in 1991 of the resulting photographs documenting the struggle of the Karen against the government created recognition for Sutton. Stories were published and commissions began to appear to document another war closer to home as Yugoslavia began to slide into conflict. For the next five years Sutton repeatedly travelled to the former Yugoslavia, Cambodia, Afghanistan, Angola, Albania and Laos. Photographs were regularly published in newspapers and magazines around the world. As well as the international press, Sutton also regularly worked with aid agencies covering a range of aid and development themes.

By 1993, and as a result of his first-hand experiences, Sutton had taken the decision to focus on landmines and always managed to spend time photographing the subject whatever the assignment. His encounters with MAG in Angola, Cambodia and Laos culminated in a number of large photospreads on MAG and landmines.

In early 1997, Lou McGrath invited him to join MAG as a permanent member of staff. Lou had recognised the need to educate and inform the public and decision-makers about the needs on the ground and felt that photojournalism was the strongest way to do it.

For the past nine years Sean has travelled with MAG's projects, from Kosovo to Sri Lanka and Iraq, Lebanon and Sudan, documenting the humanitarian impact of landmines, unexploded munitions (UXO), small arms and other deadly remnants of conflict and the solutions that MAG provides.

Putting this into the broader context of refugees, internally displaced people, water and food security, agriculture, and aid delivery, his work highlights the advantages of partnership and integration across disciplines.

The resulting material has made it possible to design and produce photo packages, exhibitions, films and publications as part of MAG's multi-media approach to public education on the subject.

Exhibitions of Sean Sutton's work with MAG include:

June 1997	Responding to Landmines, Royal Geographical Society, London, UK. (MAG conference with keynote speech and private view by Diana, Princess of Wales).
June 1999	Surviving the Peace, Richard Goodall Gallery, Manchester, UK.
April-May 2001	Surviving the Peace, Foreign Correspondents' Club, Phnom Penh, Cambodia.
June 2003	Surviving the Peace, Royal Armouries Museum, Leeds, UK.
July-August 2004	Angola: Living Through Change, Fortaleza de Luanda, Luanda, Angola.
November 2004	Angola: Living Through Change, Summit for a mine free world, Nairobi, Kenya.
June 2005	European Parliament, Brussels, Belgium. Projection in Manchester's Imperial War Museum, UK. Remnants of War Museum, Ho Chi Minh City, Vietnam.
September 2005	Living with the bomb – Laos, projection for Visa pour l'Image, Perpignan, France.
January 2006	Aid & Trade, Geneva, Switzerland.
February 2006	Iraq: Clearing Through The Danger, Dublin, Ireland (with Irish NGO Trócaire).
September 2006	Journey Through Africa's Dark Heart – DR Congo, projection at Visa pour l'Image, Perpignan, France.
September 2006	Lebanon Crisis, 7th meeting of States Parties to Mine Ban Convention, UN, Geneva, Switzerland.
November 2006	Surviving the Peace, Foreign Correspondents' Club, Phnom Penh, Cambodia.

Sean lives in Sweden with his wife and three children.